ABORTION
AND THE MEANING
OF PERSONHOOD

ABORTION AND THE MEANING OF PERSONHOOD

Clifford E. Bajema

BAKER BOOK HOUSE
Grand Rapids, Michigan

Paperback edition issued May 1976
ISBN: 0-8010-9672-4

Printed in the United States of America

Dickinson Brothers Inc.
Grand Rapids, Michigan

To my dear friend,
John Archibold,

 whose wise counsel
 and dogged devotion to truth
 has been flint to my mind
 and a hammer to my conscience.

CONTENTS

Preface

1 The Basic Issue1

2 Abortion—and the Threat of a New Ethic5

3 When Is Man a Person?......................15

4 Personhood: The Rock of Fact
 on Which It Stands ..,....................29

5 Is Abortion Murder?.......................43

6 An Apology for the Necessity
 of Legislating Morality55

7 Grounds for Abortion—Are There Any?.......61

8 The Social Problem of the Woman75

9 An Infamous Day in American History........83

 Appendix: Two Liturgies for
 Right-to-Life Sunday87

 A Service of Worship89

 One of the Least of These My Brethren101

Index109

PREFACE

When Colorado became the first state to liberalize its abortion laws according to American Law Institute guidelines (in 1967), very few people were much aware of the mountainous moral landslide that had been initiated. The emotional pebble that loosened the foundation of absolute reverence for each human being, regardless of such factors as "meaningful life" or "quality of life," was the rare problem of pregnancy resulting from rape. Because the rape argument for abortion had such tremendous emotional appeal (understandably), the advocates of abortion were able to use it successfully to set in motion a dramatic ethical shift that has ultimately brought us, within less than six years, to a national policy of abortion-on-demand, by United States Supreme Court fiat (January 22, 1973, *Roe v. Wade* and *Doe v. Bolton*).

Not until 1971 did I become personally drawn into the realm of concern and discussion regarding abortion. In my capacity as a campus minister at the University of Colorado in Boulder, I came into contact with many young women who requested my counsel about abortion. A deep sense of personal accountability drove me to study the subject and consult with others.

Some of the earliest influences on my thinking have

turned out to be the most helpful and lasting as well. I owe a deep debt of gratitude to John and Molly Archibold, Mary Rita Urbish, members of the Colorado Right To Life State Committee, and Dr. and Mrs. J. C. Willke. They have stedfastly proclaimed to every troubled woman, high school class, church group, community organization, and legislative assembly who would listen, the basic message of respect for human life, of unconditional love for persons. They have refused to stand comfortably on the sidelines shouting "peace, peace, when there [was] no peace" while watching a nation of peoples tragically plunging itself into nihilism.

I sincerely believe that most people in this country are latently pro-life. But I also sense the distinct possibility of a kind of public apathy setting in, even though it is estimated that about 1.8 million innocent human lives will be killed by abortion in the United States in 1974. Can we afford not to care any more than the citizenry of Germany in the 1930s and 40s could not afford not to care?

Several crucial questions (the answers to which will seriously affect the lives of all of us in the future) cry out for the sober attention of every thinking person: Is the life of every human being of intrinsic, *absolute* value, or is it of *relative* value depending upon its quality of life? Must every human life be reverenced equally, or is it permissible in view of new social realities (the demands of society over against the individual) to introduce the distinction between "lives with value" and "lives devoid of value," and then the distinction between "lives worth living" and "lives not worth living," and then the distinction between "lives which must be preserved" and "lives which must be terminated" (or, to speak more honestly, "killed")?

It is my hope that this small book on the meaning of personhood, limited as it is in its scope, will make a contribution in sensitizing those who read it to the magnitude of the moral issues involved, if not also motivating them to love, esteem, and protect "the least of these my brethren,"

the unborn children and **all others** who are being given lower price tags in today's world.

My special thanks are also due to Mr. John M. Langone, Dr. Edward Y. Postma, Mr. John V. Tunney, and Mr. Meldone E. Levine for their graciousness in permitting me to quote sizeable portions from their published articles.

Clifford E. Bajema
Akron, Ohio, 1974

1

THE BASIC ISSUE

If abortion is the killing of an innocent human being, then, without a doubt, abortion is the biggest social problem of all time, involving more loss of life than all of man's wars put together. Not all people agree that abortion is the killing of an innocent human being. To them, abortion weighs very little on the scale of values measuring the weight of human social problems. Present-day abortion advocates have viewed abortion as a serious social problem only because they believed there still were too many laws restricting it. The January 22, 1973, Supreme Court decision on abortion has removed that problem as well.

Most people would agree that abortion is an extremely volatile issue in our time, evoking extreme responses. On the one hand, there are those who label all people in favor of abortion as "murderers." They carry on a hate campaign completely negative in its thrust and unproductive in generating real concern for the accused wrongdoers.

On the other hand, there are those who label all people opposed to abortion as "insensitive bigots" or "male

chauvinists" who are too blind to see that any intrusion upon the rights of the woman over her own body—her privacy, or her freedom to live as she chooses—is illegitimate, even if it should be admitted on principle that the fetus is a living human being.

Such extremist "name-calling" is not helpful. Those who resort to it usually do so because they have based their position on an unconsidered and little understood assumption. So when their position is attacked, they respond with emotive outbursts because they really have no "reasons."

If the zygote-embryo-fetus is a veritable human being, then there should be reasons to support this; if it is not a veritable human being until birth or some later time, then there should be reasons supporting this claim.

There are, however, many people on both sides of the abortion debate who have come to opposite conclusions on the question of the identity of the zygote-embryo-fetus but who have been more responsible than the name-callers in that they have tried to base their conclusions on some kind of rational and empirical grounds, however legitimate or illegitimate these grounds might finally prove to be.

Without a doubt, the basic issue in the abortion discussion concerns the identity of the zygote-embryo-fetus. That issue might be put in any one of the following questions:

(1) Is what is present in the womb of the mother as the result of sexual intercourse a bit of tissue belonging to the mother's own body (like her appendix)? Or is it an independent organism?

(2) Is the zygote-embryo-fetus a "product of conception," a nameless entity? Or is it a human being, a person with an identity?

(3) Is the new one in the womb an intruder (a disease like a cancerous tumor in the intestine), which ought therefore to be removed surgically as a constructive, healing measure? Or is the new one a rightful occupant in the residence of the womb introduced into its home by an act of

sexual intercourse that took place quite apart from its own willful involvement?

The whole matter of the moral rightness or wrongness of abortion hinges on the outcome of the basic questions just asked. Most everyone would agree that it is wrong (no matter what one's religious or nonreligious point of view) to kill innocent human beings. If the zygote-embryo-fetus is not a living human being, no one should have serious problems with abortion. If it is a living human being, then, by all means, every man should do everything within his power to stop the senseless and immoral manslaughter. And, the United States Supreme Court not withstanding, what is legal is not necessarily moral.

But does most everyone agree about the matter of killing people?

2

ABORTION—AND THE THREAT OF A NEW ETHIC

It may be a mistake to quickly assume the charitable point of view that most everyone believes it wrong to kill innocent human beings. Obviously this is not the attitude of one member of the influential medical profession who voiced some revolutionary ideas recently in *California Medicine*, the official journal of the California Medical Association. I will attempt a brief paraphrase and summary of this article entitled "A New Ethic for Medicine and Society."[1]

(1) There is an old ethic, based in the Judeo–Christian heritage, which has prevailed in the West and has been the keystone of Western medicine, namely reverence for each human being, equally, with no regard to the person's quality of life (i.e., relative health, in-

An editorial reprint taken from *California Medicine* 113, no. 3, p. 67-68. Copies are available from Minnesota Citizens Conerned for Life, Inc., 4804 Nicollet Avenue, Minneapolis, Minn., 5409.

telligence, age, social productivity, and rehabilitableness).

(2) This ethic, which is still dominant, must be replaced by a new one because of emerging demographic, ecological, and social realities such as:

(a) The geometric rate of population expansion
(b) Dwindling resources
(c) The growing social importance of quality of life.

(3) In the meantime, as long as the old ethic prevails, it is necessary to engage in semantic exercises and schizophrenic subterfuges to give the impression, false though it be, that abortion does not take the life of a living human being.

(4) The new ethic, which is certain to prevail, would place relative rather than absolute values on human lives, on the use of scarce resources and on what actually constitutes quality-of-life living, so that practices like abortion could be justified even if they involved the killing of innocent human lives.

(5) The criteria for these relative values would depend upon whatever concept about the quality of life prevails at any given time in society.

(6) Those with the responsibility of establishing such criteria are people such as physicians, who, by the role they are playing in abortion, are already shaping the attitudes of people in the direction that they should be shaped.

(7) Even further extension of these roles in the matter of death selection and death control may be expected.

(8) No other profession is better equipped than the medical (because of its superior knowledge of human nature, behavior, health, disease, and physical and mental well-being) to examine, recognize, prepare, and apply this new ethic.

Some brief evaluative comments on this *California Medicine* editorial are called for.

As evidenced by the editorial, there are two ideas basic to Judeo-Christian thought that are under severe attack in our society today: (1) the idea of absolute moral value and (2) the idea of unconditional love.

Absolute Moral Value

Judeo-Christian thought always has maintained that there is a God who created this world, who has established an order (natural and moral laws) for this world, and who therefore is the One who by revelation is in the appropriate position to show man how to order his existence. God has done this, for example, in the Ten Commandments, which are absolute, unchanging moral principles for man's life. Human community (a harmonious fellowship of love and mutual service) becomes possible because men can, by looking beyond themselves, agree about what is right and wrong. Loving God above all and obeying His will makes it possible for men to love their neighbors as themselves.

But when each man decides to become his own god, he becomes his own final court of appeal in the matter of truth and morality. Man begins to quarrel and fight with his fellowman because each man has different notions of what is right and wrong. Unable to handle the god-role adequately, individual man relegates his god-role to society. This society is either a monarchy or an oligarchy or a democracy or a technocracy or an dictatorial regime. Then societies, because they operate with different value systems, begin to disagree, and there is war. And there is war. And there is war. And one begins to wonder when man will ever learn that he cannot, individually or societally, bear the burden of truth and morality alone, apart from God.

A German philosopher by the name of Hegel (1770-1831) attacked the idea of absolute moral value with the notion that men with competing views of morality (thesis vs. antithesis) can by rational processes arrive at a synthesis, an agreement based on utility or usefulness. As life goes on and situations and the needs of people change, yesterday's synthesis becomes the thesis to another antithesis out of

which comes forth a new synthesis, or agreement. Hegel's basic idea is that the center of morality's circle is not fixed; it keeps moving as situations keep changing. Yesterday's wrong becomes today's right. New ethics replace old ethics. Killing innocent human beings was wrong yesterday, but today it is no longer socially abhorrent. "Rational utility" makes it palpable to the moral sensitivities of people. The question is not any longer: "May we kill innocent human beings?" but rather, "Under what conditions should we kill human beings so as to insure a desirable quality of life?"

In the *New England Journal of Medicine,* Dr. Leo Alexander wrote an article entitled "Medical Science Under Dictatorship." I quote two sections from his essay that are relevant to this present discussion:

> Irrespective of other ideologic trappings, the guiding philosophic principle of recent dictatorships, including that of the Nazis, has been Hegelian in that what has been considered "rational utility," and corresponding doctrine and planning has replaced moral ethical and religious values. . . .

> Under all forms of dictatorship the dictating bodies or individuals claim that all that is done is being done for the best of people as a whole, and for that reason they look at health merely in terms of utility, efficiency and productivity. It is natural in such a setting that eventually Hegel's principle that "what is useful is good" wins out completely. The killing center is the *reductio ad absurdum* of all health planning based only on rational principles and economy and not on humane compassion and divine law. To be sure, American physicians are still far from the point of thinking of killing centers, but they have arrived at a danger point in thinking, at which likelihood of full rehabilitation is considered a factor that should determine the amount of time, effort and cost to be devoted to a particular type of patient on the part of the social body upon which this decision rests. At

this point Americans should remember that the enormity of a euthanasia movement is present in their own midst. [2]

A dictatorship is possible anywhere, even in a democracy. America is not really a democracy anyway; it is a technocracy run by an elite, a very small group of experts (like medical doctors and Supreme Court justices) to whom we have given more and more authority over vast areas of life involving significant moral decisions. We have done this because we have bought the lie that technical competence and professional expertise qualify one to be an expert on human nature and the total well-being of man, as though man were merely some physical–biological automaton!

In *The Making of a Counter Culture* Theodore Roszak spoke to this problem:

> In the technocracy, nothing is any longer small or simple or readily apparent to the nontechnical man. Instead, the scale and intricacy of all human activities—political, economic, cultural—transcends the competence of the amateurish citizen and inexorably demands the attention of specially trained experts. Further, around this central core of experts who deal with large-scale public necessities, there grows up a circle of subsidiary experts who, battening on the general social prestige of technical skill in the technocracy, assume authoritative influence over even the most seemingly personal aspects of life: sexual behavior, child-rearing, mental health, recreation, etc. In the technocracy everything aspires to become purely technical, the subject of professional attention. The technocracy is therefore the regime of experts—or of those who can employ the experts. [3]

[2] Leo Alexander, "Medical Science Under Dictatorship," *The New England Journal of Medicine*, 14 July 1949.

[3] Theodore Roszak, *The Making of a Counter Culture* (Garden City, N.Y.: Doubleday & Co., Anchor Books, 1969), pp. 6-7.

Unconditional Love

The second idea, basic to Judeo-Christian thought and which is under attack in the *California Medicine* editorial and in the general culture today, is the idea of unconditional love.

Like the concept about moral absolutes, this belief traces back to the conviction that there is a God out there who has freely created everything. When God made man, He preferred him above all other living beings and brought man into direct spiritual fellowship with Himself so that man might be capacitated to reflect God's character. God's character is love; He is no respector of persons.

He sent the prophets to warn against a self-righteous, cold religiosity, which kept up its ceremonial rites but neglected the weightier matters of righteousness: caring for the widows, the orphaned, and the homeless. He sent Jesus to show His love for the least of all brothers (the leprous outcasts, the poor, the mentally ill, the social outcasts like tax collectors, prostitutes, and thieves, and the little children).

And out of this context of a caring example, God's call to unconditional love came:

> Beloved, let us love one another; for love is of God, and he who loves is born of God and knows God. He who does not love does not know God; for God is love. . . . We love, because he first loved us. If any one says, "I love God," and hates his brother, he is a liar; for he who does not love his brother whom he has seen, cannot love God whom he has not seen. And this commandment we have from him, that he who loves God should love his brother also (1 John 4:7-8, 19-21).

People love people in many different ways and with many different kinds of love. Two of those loves are called *eros* and *agape*.

Eros is a Greek word describing the natural love of desire; it is a discriminatory love that takes the chosen object of its desire to itself. The basis upon which it makes its

choices is quality of life. *Eros* discerns value in a certain object, and if the value is fitting, sufficient, and pleasing enough, *eros* then seeks after and tries to appropriate the object of value. *Eros* seeks for self-gratification through its object. Basically *eros* is selfish, though not necessarily inappropriately so. *Eros* says: "Show me a man or woman, and if he or she is beautiful by my standards, I will love him or her, and by loving him or her will appropriate the value that he or she embodies to myself for my enjoyment."

Agape is a Greek word describing the love of God that can be exercised derivatively by man when he consciously offers himself in fellowship to God and his fellow man in a community of caring persons. *Agape* is a love of self-giving; it is nondiscriminatory, directed to all people. Unlike *eros*, which is dependent upon quality of life, *agape* seeks to build value into its object, and is in this way creative. *Agape* is unselfish, directing its energies toward other-gratification, knowing that in the end (as a by-product, not a goal) its self will be fulfilled. The self is most fulfilled, *agape* believes, at the precise moment that the self is given away. *Agape* says: "Show me a person (male or female, black or white, rich or poor, genius or mongoloid, infant or adult, born or unborn, wanted or unwanted) and, quite regardless of his value, beauty, desirability, or usefulness, I will with God's help love him and esteem him as myself, as a person of highest value and beauty, uniquely precious and inviolable *because he is there.*

Eros is conditional; *agape* is unconditional; both are legitimate and necessary kinds of love. The one elects qualified men to public office; the other secures to each man one vote. The one presents scholarships to promising scholars; the other provides workshops for the mentally retarded. The one promotes the successful to a higher position; the other upholds the weak and defeated who have no position. The one conducts cautious interviews for important jobs; the other employs people who come with no recommendations. The one builds stadiums for the wealthy to compete; the other builds hospitals for the sick

11

to recover. The one nurtures the wanted child; the other adopts the unwanted child.

Both loves are good and necessary for the continuance of human community. But neither love must devour the other. In our day *eros* has well-nigh gobbled up *agape,* and people are choking from the tyranny of an *eros* consciousness. Qualities of mercy, faithfulness, honor, compassion, and self-denial cease to be positive values in a quality-of-life culture that has come to be disdainfully impatient with the difficult demands of unconditional love.

The divorce problem today is a case in point. It is one good thing for two people to "fall in love," get married, and enjoy the fine qualities and beauties of one another as long as they both shall live; it is quite another good thing for two married people to forgive wrong, to overlook weakness, to accept responsibility, and to commit themselves to the vulnerability of selfless service without escape clauses or a terminal point making them just another divorce statistic.

In his sobering book, *Brave New World,* Aldous Huxley looks ahead a few generations, and he sees the future as a time in which sexual promiscuity becomes the order of the day, and such "oddities" as fathers and mothers and wives and husbands become obsolete. The importance of the individual as a being who is responsible to God, to himself, and to others (which would include his mate and children) is lost as the individual becomes a mere social functionary lost in a giant social organism. As a social functionary, each person becomes free to have any man or woman who is sufficiently desirable. In fact, in this brave new world, relationships that last more than two or three months are discouraged because they create the risk of cultivating too much *personal* concern for one another. Only the society is important, not the person. The importance of the person lies exclusively in his ability to *function* for the good of the social organism. Such is a quality-of-life culture where unconditional love has disappeared.

In many ways Huxley's vision is fantastic, but hardly

impossible. He himself points out in the foreword to his book:

> There are already certain American cities in which the number of divorces is equal to the number of marriages. In a few years, no doubt, marriage licenses will be sold like dog licenses, good for a period of twelve months, with no law against changing dogs or keeping more than one animal at a time. As political and economic freedom diminishes, sexual freedom tends compensatingly to increase.[4]

The ethic of F. Nietzsche was one of the major influences contributing to the tyranny of an *eros* consciousness in Germany shortly before Hitler's rise to power. Nietzsche's ethic, a form of naturalism, elevated nature's method, her *modus operandi*, to a position of moral status: as the way for man to achieve his ends and justify his means. Thus, for Nietzsche, the locus of moral value became power (might is right); the highest good became the rule of the strong (self-assertion, pride, and determination) resulting in the advent of a better race; the chief evil became any protection of the weak (meekness, gentleness, and love) which slowed down the process of nature whereby the weak inevitably met their natural fate.

Later, in 1935, the Nazi Director of Public Health, Dr. Arthur Guett, wrote (predictably) in his book entitled *The Structure of Public Health in the Third Reich*:

> The ill-conceived "love of neighbor" has to disappear, especially in relation to inferior or asocial creatures. It is the supreme duty of a national state to grant life and livelihood only to the healthy . . . in order to secure the maintenance of a hereditarily sound and racially pure fold for all eternity. The life of an individual has meaning only in the light of that ultimate aim, that is, in the light of his meaning to his family and to his national state.[5]

Aldous Huxley, *Brave New World* (New York: Grosset & Dunlap, Bantam Books, 1966), p. xiii.

Arthur Guett, *The Structure of Public Health in the Third Reich*. Taken from materials on abortion by Robert L. Sassone and used by permission of L.I.F.E.

Remember the ideas in the *California Medicine* editorial, "A New Ethic for Medicine and Society"? Are these ideas much different from those expressed above? And will the results be the same? Have the lessons of history really been learned?

In 1945, after the German universities had been reopened, Dr. Helmut Thielicke delivered a series of lectures (now gathered in the book called *Nihilism*) at the ancient University of Tübingen and then again at the Free University in West Berlin. Students, desperately hungry to have their intellectual and spiritual needs satisfied after the debacle of the Third Reich, packed the lecture halls. And Dr. Thielicke said to them:

> Once a man ceases to recognize the infinite value of the human soul—and this he cannot do once the relationship to God is extinguished and thus man's *character indelebilis,* which God has stamped with eternity, is smashed—then all he can recognize is that man is something to be used. But then he will also have to go further and recognize that some men can no longer be utilized and he arrives at the concept that there are some lives that have no value at all. Nobody can be preserved from this ultimate conclusion by a peaceable character or because he can't stand to see blood. [6]

How many students from university medical schools, departments of law, and political science departments would jam their lecture halls to hear such sentiments expressed today? Do men have to see the blood of their aged, their unborn, their retarded, and their racially impure flow in the streets again to be shocked into some kind of moral sensibility? May God spare the people of this land a "new" ethic for medicine and society, and grant us instead a fresh outpouring of His unconditional, creative love.

[6] Helmut Thielicke, *Nihilism* (New York: Harper & Row, Schoc en Books, 1969), p. 84.

3

WHEN
IS MAN
A PERSON?

The basic question concerning the identity of the zygote-embryo-fetus can be broken down into smaller parts, and progress can be made toward a satisfactory answer from this perspective.

First of all, is it *alive*? Webster defines "life" in this way: "The quality or character distinguishing an animal or a plant from inorganic or from dead organic bodies, which is especially manifested by metabolism, growth, reproduction, and internal powers of adaptation to environment." Other definitions are added, but this first definition is the biologic dimension of life apart from which it is meaningless to talk of the spiritual, psychological, social, and other dimensions of life. At least by the biologic dimension, the zygote-embryo-fetus is alive (metabolizing, growing, and adapting).

But is it *human* life? Does it belong to or relate to man? Without trying to sound facetious, I might ask: "What other choice is there?" It certainly isn't zebra life or azalea life or chicken life or guppy life. Obviously not. It is human

life. But so is my fingernail! Which raises still a third question.

Is it *a human being*? Is it an individual, a person? The answer to this question will require considerably more attention because it brings us back to the heart of the matter, to the point where the real difference of opinion exists. No one, except certain people who seem to have surrendered all rationality, has a problem with the claim that the zygote-embryo-fetus is *alive* and is *human* life. But when it is suggested by pro-life people that the zygote-embryo-fetus is veritable, individual human life (a human being or person), then the feathers begin to fly.

The legal implications of this question are far-reaching. The Fourteenth Amendment to the Constitution of the United States says: "Nor shall any state deprive any person of life, liberty, or property without due process of law, nor deny to any person within its jurisdiction that equal protection of the laws." The only way that abortion can be allowed by law, then, is if it can be proven that the zygote-embryo-fetus is *not* a person. The United States Supreme Court was faced with this question recently: Is the unborn a human person entitled to the protection of the Fourteenth Amendment, or not? Their "non-answer" was that the term "person" as used in the Constitution "has application only postnatally."

There are three possible positions on the question of when the human being (person) begins, all of which involve doing some kind of defining of what a person is:

(1) The human person begins at birth or at some later point.

(2) The human person begins at some point during the period of gestation.

(3) The human person begins at conception.

Begins at Birth or Some Later Point

In a public debate between the Colorado Right To Li[f]e and the Mountain States Women's Abortion Coalition held at the University of Colorado some time ago, th[e]

debating representative of MSWAC was asked: "If you were pregnant and gave birth prematurely to an alive child at six and one-half months, would you consider such a child a human person entitled to the same protection of the Fourteenth Amendment as you are?" Her answer was: "Yes, most definitely." She was then asked: "If you were pregnant with an unwanted child and had that alive child aborted two days before full term (which is possible in the state of Colorado), would you consider such a child a human person entitled to protection under the Fourteenth Amendment?" Her response was: "No." The questioner then commented to the audience: "It does not seem to matter how long the zygote-embryo-fetus is present in the womb as to establishing its identity as person, but rather whether or not the zygote-embryo-fetus is *born*." He went on to ask: "What magic occurs at birth which changes a potential person into an actual person?" No answer was given.

Dr. R. F. R. Gardner, a consultant obstetrician and gynecologist, expresses a point of view about personhood quite similar to that expressed above.

> From time to time obstetricians have the distress of delivering a stillborn baby. We may have felt this fetus kick under our examining hands, we may have listened to its heartbeat repeatedly over four months, yet when the tragedy occurs we do not feel, "Here is a child who has died," but rather, "Here is a fetus which so nearly made it."[1]

This may be how one or several obstetricians feel. But the question "Why?" cannot be drowned under a wave of feelings. Why do you say, doctors, that fetuses become persons at birth? What "reasons" do you have?

The memory of childbirth is vivid in my mind. Recently, my wife gave birth to our third child, a beautiful little girl named Sarah. I was privileged to be with my wife during

R. F. R. Gardner, *Abortion: The Personal Dilemma* (Grand Rapids: Wm. B. Eerdmans Publishing Co., 1972), p. 126.

the whole time of labor and delivery. Soon after my wife had gone into labor and we had left for the hospital, I remembered something I had learned from the famous fetologist, Dr. Albert Liley, that it is the baby who gives the signal hormonally when it is time for the mother to go into labor. And I thought: "Is it a person now?" But then I remembered how this same baby had hormonally stopped its mother's menstrual period just one week after implantation, and from that time on had taken complete charge of the pregnancy. And I thought: "Was it perhaps a person then?" At the hospital the doctor would come in now and then and check the dilation of the cervix. He would comment about how the child had moved to a new "station" in its downward journey. I thought: "Is it person yet?" Later, in the delivery room, the head of my unborn child began to show. "It has black hair," the doctor said. I thought: "Is it person yet?" Very soon I heard a garbled cry, and the doctor, while suctioning the mucus out of the child's mouth, exclaimed: "It's a girl!" And I thought: "Little Sarah, are you a person yet?" And then the umbilical cord was cut, and I thought: "Does that make you a person, Sarah? Or must you first open your eyes, or smile, or babble 'dada,' or crawl, or walk, or go to school, or . . . ?"

In Canada, the unborn child becomes a person when the cord is cut. At that point, it is argued, the child is no longer part of the mother; it bcomes an independent being. But both these statements (that the child until birth is part of the mother and that the child until birth is dependent) are open to much question.

As to the first statement, how does it match up to the following facts?

(1) There is a unique forty-six chromosomal pattern in every little one, present from the moment of conception.

(2) The placenta, the fluid in the sac, and the cord are all organs of the baby.

(3) The mere fact of attachment does not make the child part of the mother any more than a car

becomes part of a gas pump to which it is attached for fueling purposes.

(4) The mother provides the child in her womb the same supports she provides outside the womb: a protective environment and nourishment. In the womb, the nourishment comes through the tube (there is, incidentally, no exchange of blood); in the mother's arms, the nourishment comes through the breast or bottle.

And how does the second statement stand up to the following considerations?

(1) The child is no less dependent upon the mother for vital life support immediately after birth than immediately before.

(2) Dependency is a purely relative criterion for personhood and can be defined in any number of ways by any number of "experts."

(3) By certain criteria (and who is to say that they are not valid criteria?) the human being never becomes completely independent of others for the satisfaction of his basic needs.

(4) Using independence as a basis for defining personhood logically opens the door to justifying euthanasia for old people or mental retards who have become burdens to their families and to society because of their total dependency.

Many people (particularly Protestant theologians) attach some kind of mystical significance to the child's first breath, and say that this is the magical bridge from potential human life to actual human life. Once again I quote from R. F. R. Gardner (Dr. Gardner is also an ordained minister in the United Free Church of Scotland):

> My own view is that while the fetus is to be cherished increasingly as it develops, we should regard its first breath as the moment when God gives it not only life, but the offer of Life. Now this is not an example of the Christian retreating in the face of a scientific attack. This surely is the original biblical teaching that God took a fully-formed man and breathed into

his nostrils the breath of life, and thus man
became a living creature—Adam.[2]

The theological accuracy of Gardner's statement is questionable, but I will reserve theological comment until later. I will simply refer now to an experience, related by Dr. Albert Liley, of a doctor who attempted to locate a placenta on X ray by injecting an air bubble into the unborn baby's amniotic sac. When it so happened that the air bubble covered the baby's face, the child began to breathe air and, of course, cry. (Normally, the unborn child breathes fluid within his mother's womb; this is done to develop the organs of respiration. During this time the child obtains his oxygen through his umbilical cord.) The mother stated to her doctor that the baby cried so loudly that she had trouble resting.[3]

Question: Is this unborn, crying, breathing baby a person?

There is another haunting question, too, that will not lie down and be quiet: If the miracle of personhood occurs at birth (when the cord is cut and/or when the child breathes), what about a hysterotomy abortion? A hysterotomy is a minor Caesarean section, and is one of the four methods of abortion. All children aborted by hysterotomy are *born* alive; they move, breathe, and some cry. The cords are cut and, it seems, they reach the point at which personhood becomes a reality. But what happens? Because they are not wanted, they are thrown into a bucket and encouraged to die. In the state of New York in 1971, approximately four thousand *persons* were killed in this manner.

Maybe the moment of birth is too arbitrary a point at which to locate the beginning of personhood after all.

[2] Ibid., p. 126.

[3] This experience related by Dr. Liley is recorded in the *Amicu Curiae* brief submitted by 220 physicians, professors, and fellows of the American College of Obstetrics and Gynecology t the United States Supreme Court in the Texas and Georgia case (*Roe vs. Wade* and *Doe vs. Bolton*).

Maybe the people are right who say that personhood really begins at some point in the child's *post partum* existence. Maybe Dr. Robert H. Williams is right when he says:

> The fetus has not been shown to be nearer to the human being than is the unborn ape. Even the full-term infant must undergo many changes before attaining full status of humanity. Only near the end of the first year of age does a child demonstrate intellectual development, speaking ability, and other attributes that differentiate him significantly from other species.[4]

One wonders in reading this statement whether the next lie to be sold in our culture will be the idea that infanticide (like feticide) is really not murder at all because children less than one year old are not persons.

Begins at Some Time During Gestation

The variety of times chosen by those who believe that human personhood begins at some time during gestation is about as wide as the number of choices available. Before the Supreme Court gave this nation what amounts to an abortion-on-demand national policy, various states set all kinds of different limits on abortion, depending on the particular criteria they chose by which to make such a judgment. In the state of Colorado there was no time limit on abortion, except when the pregnancy resulted from rape or incest, in which case the time limit was sixteen weeks. It is anybody's guess what the rationality behind Colorado's position was. In Alaska and Hawaii, abortion was available on demand until the time of viability; in Maryland the limit was twenty-six weeks; in New York, another abortion-on-demand state, the limit was twenty-four weeks; in eleven states the limit was twenty weeks; in thirty-four states the limit was conception.[5] But the Su-

4 Robert H. Williams, "Our Role in the Generation, Modification and Termination of Life," *Archives of Internal Medicine,* 1969.

5 Statistics from Dr. and Mrs. J. C. Willke's tape *Abortion, How It Is,* available from Hiltz Publishing Co., 6304 Hamilton Ave., Cincinnati, Ohio 45224.

preme Court decision canceled out all these state laws by saying that the term "person" in the Constitution "has application only postnatally."

Who is right? Or doesn't it matter any more than that Nebraska has a speed limit of 75 mph while Illinois has a speed limit of 70 mph? Are we ready to concede that the question of when human personhood begins is purely a matter of *definition*, not of *fact*? But then, how have we protected ourselves from the power elitists (legislators, doctors, psychiatrists, and judges) who in a given society may use the principle of "defining as one wishes" to define all kinds of people (the "useless eaters," the incurably ill, the racially impure, the habitual criminals, and the less than one-year-old children) as nonpersons and therefore not entitled to protection under the Fourteenth Amendment? On the surface, this new ethic for society may not sound too threatening. But the first small step away from principle is a complete change of direction after which all other steps are but inevitable downward progressions.

Is there a single criterion that can establish our decision on the rock of fact rather than on the slush of definition? What about *viability*? As the term "viability" is used in connection with the abortion issue, it means the capability of living as a newborn infant outside the womb. In the past viability was believed to be about twenty-eight weeks. The skills of the developing sciences of fetology, neonatalogy, and obstetrics have brought viability down to about twenty weeks. Dr. J. C. Willke (coauthor of *The Handbook on Abortion*) predicts that viability will be brought down to twelve weeks by the turn of the century. So as medical discipline advances, viability keeps changing. Is this the solid rock of fact we are looking for? Dr. Willke is more to the point when he says: "Viability is a measurement of the sophistication of the external life support system, not directly of the baby him or her self." [6]

What about *quickening*, the time when the mother first feels movement within her? In an *amicus curiae* brief sub-

[6] Ibid.

mitted to the Illinois Supreme Court, Dr. Bart Heffernan
argues:

> . . . quickening is a relative concept which
> depends upon the sensitivity of the mother, the
> position of the placenta, and the size of the
> child But modern science has proven
> conclusively that any law based upon quicken-
> ing is based upon shifting sands—a subjective
> standard even different among races. We now
> know that life precedes quickening; that quick-
> ening is nothing other than the mother's first
> subjective feeling of movement in the womb.
> Yet the fetus we know has moved before this. In
> spite of these advances in medicine, some
> courts and legislatures have continued to con-
> sider quickening as the point when life is magi-
> cally infused into the unborn. . . . No concept
> could be farther from the scientific truth. [7]

So where are we? One man says that the fetus becomes a
person when the child breathes; another, when the cord is
cut; another, when the child can survive outside the
womb; another, when the mother feels the child's move-
ment; another, when the heart begins to beat; and another,
when there is discernible brain activity. Who is right? Or
doesn't it matter?

Then maybe it doesn't matter so much either that men
such as Representative Sackett in Florida are submitting
death selection (euthanasia) bills to their legislatures.
These bills are based on their *definitions* of when
personhood ends, which only stands to reason.[8] If the be-
ginning of personhood is purely a matter of definition and
not of fact, then also is the ending of personhood.

Can this society, or any society, stand a quality-of-life
ethic? History has said it can't. Modern secular society
evidently refuses to learn this hard lesson of history. It
childishly and masochistically persists in a philosophy

[7] Bart Heffernan, *Amicus Curiae* brief submitted to the Illinois
Supreme Court, pp. 38, 39.

[8] The bill submitted by Representative Sackett is reprinted on
page 18 of *Handbook on Population* by Robert L. Sassone.

that threatens its own dehumanization and eventual destruction.

Begins at Conception

The earliest possible time, logically and biologically, to consider when the human being begins is, of course, conception. Although the sperm and ovum are both alive, they are radically different from the fertilized ovum. It is at this juncture, indeed, that the distinction between potential human life and actual human life is applicable.

Dr. and Mrs. Willke, who have done a great service to the pro-life cause through their *Handbook on Abortion* and their tapes, have this to say on one of their tapes about the sperm, the ovum, and the fertilized ovum:

> The sperm has life, the ovum has life. The sperm does have life, but it is a life that is a sharing in the life of the father. The sperm with only half as many chromosomes, is nevertheless identified chromosomally as a cell of the body of the father. Furthermore, the sperm is at the end of its maturation cycle, having but one purpose in existence, to fertilize an ovum. Failing that the sperm must die. It is at the end of the line; it cannot reproduce itself. The human ovum, similarly, is a cell of the mother's body, so identified chromosomally. It too has life, but it is a sharing in the life of the body of the mother, it too having but one purpose in existence, i.e., to be fertilized or to die. But when the two join, we have at that instant created a new living being. Judge this being to be human at that moment or not, we cannot deny the biologic fact of the total uniqueness of this new living being, a new being that is not at the end of the line, but at the dawn, a new being containing within him or her self the totality of everything an old man or woman will ever be, a new living being that is programmed to live eight and one-half months within the mother and as many as ninety years without. When, then, does human life begin?[9]

In the October 1971 term of the Supreme Court of the

[9] Willke, *Abortion, How It Is* (tape).

United States, a distinguished group of 220 physicians, professors, and fellows of the American College of Obstetrics and Gynecology submitted an *amicus curiae* brief to the Court. In this brief they tried to show how modern science established that the unborn child from the moment of conception is a person and therefore, like the mother, a patient. John M. Langone has succinctly summarized this brief in a *Cambridge Fish* article entitled "Abortion: The Medical Evidence Against," (reprinted from the *Boston Herald Traveler*). Because of my meager knowledge of the biological side, I wish to quote extensively from this article the portion that pertains to the development of the child from conception through three months:

> From conception, when the sperm and egg unite, the child is a complex, dynamic, rapidly growing organism.
>
> By a natural and continuous process, the single fertilized egg will, over approximately nine months, develop into the trillions of cells of the newborn. The natural end of the sperm and egg is death unless fertilization occurs. At fertilization, a new and unique being is created which, although receiving one-half of its chromosomes from each parent, is really unlike either.
>
> About seven to nine days after conception, when there are already several hundred cells of the new individual formed, contact with the uterus is made, and implantation and nourishment begin. Blood cells form at 17 days, and a heart as early as 18 days. The heart starts irregular pulsating at 24 days and about a week later smooths into rhythmic contractions. (Some investigators have observed occasional contractions of the heart in a two-week-old embryo. The new human being is called an embryo until the third month, a fetus after that until birth.)
>
> At about 18 days, the development of the nervous system is under way, and by the 20th day the foundation of the child's brain, spinal cord and entire nervous system is established.

By the sixth week after conception, this system will have developed so well that it is controlling movements of the baby's muscles, even though the woman may not be aware that she is pregnant.

By the 33rd day, the cerebral cortex (that part of the central nervous system that governs motor activity as well as intellect) may be seen. The baby's eyes begin to form at 19 days, and by the end of the first month the foundation of the brain, spinal cord, nerves and sense organs are completely formed.

By 28 days, the embryo has the building blocks for 40 pairs of muscles, and by the end of the first month, the child has completed the period of relatively greatest size increase and the greatest physical change of a lifetime.

Now, the child is 10,000 times larger than the fertilized egg and will increase its weight six billion times by birth, having in only the first month gone from the one-cell stage to millions of cells.

By the beginning of the second month, the unborn child looks distinctly human, yet the mother is not aware that she is pregnant. . . .

At the end of the first month, the child is about a quarter of an inch long.

At 30 days, the child and mother do not exchange blood, the child having from a very early point in its development its own and complete vascular system.

Earliest reflexes begin as early as the forty-second day, the male penis begins to form, cartilage has begun to develop. Even at five-and-a-half weeks, the fetal heartbeat is essentially similar to that of an adult; the energy output is about 20 percent that of the adult but the fetal heart is functionally complete and normal by seven weeks. At this point, the child may be likened to a one-inch miniature doll with a large head, but gracefully formed arms and legs and an unmistakably human face.

The body is covered with skin, the arms have hands and fingers, the legs have knees, ankles and toes.

By the end of seven weeks, the doctors pointed out in their brief, there is a well-proportioned small-scale baby. It bears the familiar external features and all the internal organs of the adult, even though it weighs one-thirtieth of an ounce.

"The new body not only exists, it also functions," the doctors declared.

The brain, in its shape and general outline, is already like the adult brain and sends out measurable impulses that coordinate the function of the other organs. Brain waves have been noted at 43 days, the heart beats strongly, the stomach produces digestive juices, the liver manufactures blood cells and the kidneys are functioning. The muscles of the arms and body can already be set in motion.

After the eighth week, no further original organs will form—everything that is already present will be found in the full-term baby. From this point until adulthood, when full growth is achieved somewhere between 25 and 27 years, the changes in the body will be mainly in dimension and in gradual refinement of the working parts.

"The genetic pattern set down in the first day of life instructs the development of a specific anatomy," the report noted.

In the third month, the child becomes very active and by the end of the month kicks his legs, turns his feet, moves his thumbs, bends his wrists, turns his head, frowns, squints and opens his mouth.

He can swallow, and he drinks the amniotic fluid that surrounds him. He sucks his thumb, and the first respiratory motions are noticed.

During the ninth and tenth weeks, the whole body becomes sensitive to touch, and by the end of the twelfth week, the child's movements

are no longer like that of a puppet. They are now graceful and fluid, as they are in the newborn. The child is active and the reflexes are becoming more vigorous, and all this is before the mother feels any movement. . . .

Further refinements are noted in the third month, such as the appearance of fingernails, enhancement of the child's face and the differentiation of internal and external sexual organs. Primitive eggs and sperm are formed, and the vocal cords are completed. In the absence of air, they cannot produce sound. The child cannot cry aloud until birth, although he is capable of crying long before. . . .

"This review of the current medical status of the unborn," the doctors said in their brief, "serves us several purposes. First, it shows conclusively the humanity of the fetus by showing that human life is a continuum which commences in the womb. There is no magic in birth. The child is as much a child in those several days before birth as he is those several days after." [10]

These biological facts are impressive, but they are not sufficient to totally convince everyone that the human person begins at conception. There are some who believe (myself included) that personhood is a spiritual concept, not meaningful without reference to the relationship between God and man, and not ultimately explainable except in a "theological context."

Most of the theological argumentation has been left up to the Roman Catholic theologians (to whom we owe a deep debt of gratitude) and is buried on seminary library shelves in theological works not read by many. I shall try in the next chapter to make a theological case for personhood at conception by sharing a few thoughts from the Protestant side, hoping that it may reach the hands of a few average people who, like myself, do not consider themselves "experts" in the field of theology.

[10] John M. Langone, "Abortion: The Medical Evidence Against," *The Cambridge Fish* 2, no. 1, pp. 2, 9 (reprinted from the *Boston Herald Traveler*).

4

PERSONHOOD: THE ROCK OF FACT ON WHICH IT STANDS

The most important question to which man is seeking an answer in the latter third of the twentieth century is a theological question:

Why is the life of man valuable?

Under the pressure for an immediate answer that social problems such as abortion and euthanasia bring to bear, certain theological "waiters" are serving up solutions that constitute poisonous threats to the human lives they so genuinely want to enrich and preserve.

> After the dinner of sexual intercourse is
> liberally enjoyed
> and men begin to feel the sharp effects of
> knowing then
> the deep responsibilities such acts inevitably
> bring,
> they find the truth too hard to stomach well,
> and order up the first of several after-dinner
> cure-alls.

> So the potent liqueur of theological error
> is predictably served in delicate glasses

and usually has the sweet bouquet of
 satisfying "reasonableness,"
alluring temperate men to sip so slowly
 those lethal spirits
which make them feel so warm and
 right inside—
until the laughs subside
and tides of numbness swell their bones
so they remember truth no more.

But the truth about man is simply taught in the sacred
Scriptures.

The Image of God in Man

The whole matter of man's value (his dignity and in-
violability) rests *biblically* on the fact that man is divine
image-bearer:

> Then God said, "Let us make man in our
> image, after our likeness." . . . So God created
> man in his own image, in the image of God he
> created him, male and female he created them
> (Gen. 1:26-27).

> Whosoever sheds the blood of man, by man
> shall his blood be shed; for God made man in
> his own image (Gen. 9:6).

Theologians have tried for centuries to define the precise
meaning of "Image of God"—in fact, in more precise terms
than Scripture itself gives. I hesitate to add my own defini-
tion, knowing that it, too, will end up in the theological
junkyard with other discarded definitions that have been
found to be inadequate to transport the full meaning of
"image of God."

But I will (I hope not foolishly) rush in where angels fear
to tread and at least offer some elementary thoughts on the
meaning of the image relative to how it determines the
status and *nature* of man.

The Image of God and Man's Status

The fact of being created in the image of God determines
man's status and nature. In his created *status,* which is
man's position, rank, or state (relative to God in this case)

man is a "child of God." It is to say that God has graciously conferred on man by creating him in His image the rank or position of uniqueness and inviolability. Because of his privileged position relative to God, man may not be touched by the violent hand of his brother.

The word used in common nonbiblical parlance to describe man in this state of uniqueness and inviolability is the term "person." It is to the *person* that the Fourteenth Amendment guarantees the right not to be deprived of life, liberty, or property without due process of law. It is as though "person" were an adjective of "man," not qualifying man as to his nature (abilities) but as to his status (unique, inviolable, and possessing inalienable rights). Personhood, biblically understood, does not rest on the slush of definition; it stands on the rock of fact—the fact that man is created in the image of God and is by that fact protected from the abortionist or from any other man seeking to lower the price tag on his life.

Another biblical term indicating the unique, inviolable status of man is "temple of the Holy Spirit." Both man and animal are divinely created "living beings." But man is distinguished from the animal in that a direct communication of God's Spirit is indicated in the case of man, but not in the case of animal. Man is directly formed by God's Spirit. The being (or Life) of God extends to man through God's Spirit. God who is Life-Source (1 Tim. 6:13), who is Spirit (John 4:24), who alone has immortality (1 Tim. 6:16) chooses to breathe *into*, to dwell *within*, man; He lovingly chooses to accept a position of immanence within man as well as of transcendence over man and the rest of creation; He sovereignly chooses to make man (and man alone) in His image, after His likeness. Thus man, unlike the rest of animal and vegetable life, is not simply a living being in that he is vivified or spiritized by God; he is also living being in that the Life-Giver (the Holy Spirit), by grace, has come to dwell within him, activating and forming his material substance (body, dust) so that he comes to receive the appellation: soul.

It could, of course, be objected that all of the above is true, but it is true only for *man*. And then the question could be asked: Does the Scripture ever really say that what is sexually conceived by man is from the moment of its conception *man*?

The answer is "no" if one is expecting Scripture to provide a *scientific statement* on when individual man begins. The answer, however, is "yes" if one is expecting Scripture to provide a *theological understanding* of man from the point of his beginning to the point of his end.

Interestingly enough, Scripture does not make the kind of subtle philosophical distinctions people make so often today between human life and human being, man and person, life and Life. Scripture just simply talks about man. With the exception of Adam, who was created instantaneously by God from the dust of the ground and at that instant enlivened by a divine inbreathing (call it the gift of Life with a capital "L"), all other men begin as the result of the sexual union of a human male and a human female. The progeny or issue of the sexual union (if conception occurs) is referred to *from the moment of its conception* as man. The term "man" is not reserved for the offspring that becomes in fact *born*. Each individual man has his historical beginning as man at conception.

In Genesis 4:1 it says: "Now Adam knew Eve his wife, and she conceived and bore Cain, saying, 'I have gotten a man with the help of the Lord.'" Notice: she *conceived* Cain and she *bore* Cain. The man Cain is there from conception. In Job 3:3, Job is lamenting the fact of his existence. He wishes that he had never happened on the scene of history. And he says: "Let the day perish wherein I was born, and the night which said, '*A man-child is conceived*'" [italics mine]. These texts are not, surely, scientific statements. But they are biblical indicators that at least in Scripture the point at which it is appropriate to *begin* talking about individual man is the point of his real beginning: conception.

At the very heart of Christian thought is the teaching of

the Incarnation of Jesus Christ. God's very own Son emptied Himself of the glory He had with the Father and assumed a complete identity with man. And so Scripture reports that Jesus was conceived by the Holy Spirit. The conception of Jesus was mysteriously unique in that He somehow became fully man while remaining fully God. Be that as it may, Jesus *did become fully man at his conception*. The gift of Life, or Spirit, did not have to wait until He was born. Therefore, if it is true that Jesus became like man *in every way*, sin excepted, then the Incarnation of Jesus is a clear theological statement of when individual man begins.

The objection frequently has been raised at this point that even though Scripture teaches that man begins at conception, this teaching most likely has reference to the mere biological dimension of man (man as body, or as human *life*). Not until birth does God grant man the gift of *Life* by His divine inbreathing. In some mysterious way, the onset of breathing or the act of respiration becomes fundamentally important in the transition from that which is alive in the animal or biologic sense to that which has *Life* and thus *Personhood* in the spiritual or truly human sense.

He who wishes to do justice to the theological meaning and intent of the scriptural teaching concerning man must stop here and ask a crucial question: Does Scripture ever make such a distinction between biologic (animal) man and spiritual (fully human) man? The answer is obvious: It does not. Why? Because Scripture never conceives of *man* in such Greek dualistic fashion. Man is not an alive piece of flesh who receives a spiritual dimension (some call it Life; some, Soul) later on at birth.

The question sometimes has been asked by men seeking a reasonable justification for abortion: When does man become a soul? Maybe, they think, the soul isn't "put into" the body until birth or some time shortly before, in which case abortion is justified until the time of ensoulment.

The question is not really well placed. It is of Greek

(Neo-Platonic) and not of Hebrew origin. Man does not receive a soul—he *is* soul and he *is* body. He is not body containing soul; he is not soul imprisoned within a body. *Man is a unified being.* As soon as there is dust being formed by Spirit, Adam *is*. The following three quotations are instructive:

> The formation of man from dust and the breathing of the breath of life we must not understand in a mechanical sense, as if God first of all constructed a human figure from dust [like a ginger bread man] and then, by breathing His breath of life into the clod of earth which he had shaped into the form of a man, made it into a living being. . . . By an act of divine omnipotence man arose from the dust; and in the same moment in which the dust, by virtue of creative omnipotence, shaped itself into a human form, it was pervaded by the divine breath of life, and created a living being, so that we cannot say the body was earlier than the soul.[1]

> For a Hebrew, for a man saturated with Old Testament ways, *a person was a body* [italics mine]. The body was not something really extraneous to the soul. It was the man in action. A man was not like an angel driving a body about. It never occurred to a Hebrew to think of man as a soul who had to carry around a piece of luggage called body. *A man was animated flesh* [italics mine].[2]

> In your judgment, when does the fetus or embryo become a human being, or acquire a soul?

> Answering the question in reverse order, man does not *acquire* a soul. Man *is* a living soul. Unfortunately, Hellenistic thought was adopted by the early church and man was por-

[1] Keil-Delitzsch, *Commentary on the Pentateuch* (Grand Rapids: Wm. B. Eerdmans Publishing Co., n.d.), p.79.

[2] Lewis B. Smedes, "Christ and His Body," *Reformed Journal* 17, no. 3 (March 1966): 16.

trayed as being of two separable parts. And that uniting of soul and body, separating of soul and body, and then reuniting of soul and body have prompted all sorts of questions and speculatory solutions for professional and lay theologians. The speculations are myriad because the supposition is false. Man is one being, whole man, image of God from beginning to end and presenting a body and soul aspect. Man begins one, is born one, lives one, dies one, and this is the glorious promise and sure hope—he is resurrected one.

When and where does man begin? By legal fiat one can set any time or circumstance, but that remains just that—legal fiat. Or by sophistry one can argue for various times and conditions depending on one's previous definitions, but that remains what it was—sophistry. The one point in time and space beyond which one cannot go by fiat or sophistry is that of real beginning. Each man, whole man, that reads this began his individual life at one point in time and place and will proceed until he reaches that point in time and space when he dies. The place of beginning was in the mid-portion of his mother's fallopian tube when one of his father's sperm and his mother's ovum for that particular month united. At that time and place a new, unique genetic pattern, contained in *one* cell at the moment of beginning, began—a working genetic pattern that developed and controlled its own individual growth and variations (as it does all through each individual's life) with the proper available nutrient and adequate time to be the one who reads this.

Interruption at any time of that one who has begun would mark the literal death of an individual, separate from all others as to individuality and distinguishing characteristics, but sharing with all other men one tremendous and awesome identity—each being image of God. Robert Ochs says of each individual human life: "Life is radically serious. It is truly historical, that is, unique, unrepeatable, of inalienable and irrevocable significance. Each man's life is

suspended between a *genuine* beginning and a *genuine* end."[3]

In chapter 3 I quoted Dr. R. F. R. Gardner, who argues (on the basis of Genesis 2:7) that the fetus does not receive its supersensuous spiritual life until it breathes (at which time it supposedly becomes a living human being). In response I would simply say: Animals breathe, too. Certainly breathing is not the mark of manness or humanity. It is true that Adam's breathing was coincident with the moment of his being fully formed. But it must not be forgotten that Adam's creation was unique in that it was direct and instantaneous, not the result of conception through sexual intercourse of two parents.

There is an interesting issue (related to the unfortunate question about when man becomes soul) that is often discussed in connection with abortion: Is the zygote-embryo-fetus a *potential* man as opposed to an *actual* man?

Three definitions are required for lucid comment on this question:

(1) *Potential:* Possible as opposed to actual; latent as opposed to realized

(2) *Potency:* Capability of developing in accordance with its essence

(3) *Actual:* Existent in fact as opposed to non-existent in fact

A forty-year-old person is, at least as far as age qualifications go, a potential candidate for public state office. A four-year-old person is, at least as far as age qualifications go, not a potential candidate for public state office.

A four-year-old cannot be elected to public office. There is no possibility of such happening. A forty-year-old person can be elected to public office. There is a possibility of such happening. However, the forty-year-old may not in fact be so elected or even nominated.

[3] Edward Y. Postma, "Abortion: Yes or No?" *The Banner* 106, no. 23 (June 1971): 15.

Thus, it can be concluded that potentiality implies *possibility* but does not imply *necessity*.

A sperm and an ovum may or may not become a man. They may or may not meet up with one another. So in the case of sperm and ovum as well, potentiality implies possibility, but not the inevitability that what is possible will be realized.

Therefore, this question seems appropriate: If a fertilized ovum continues to develop naturally in the womb, is it not true (assuming for the purpose of argument that it is not yet a man) that it not only *can* become a man, but that it *will* become a man because there are no other possibilities?

Is it then proper to refer to the zygote-embryo-fetus as a "potential man"? Not really. If potentiality means possibility, and if possibility does not imply necessity, then it would seem that the term "potential" is not exactly appropriate as a description of the fetus.

But neither does necessity imply actuality. To say that a fetus must become a man (that there is no other alternative) does not imply logically that it is in *actuality* already a man.

So, how can it be maintained, as some pro-life people do, that the zygote-embryo-fetus is an actual man?

This raises the issue about the meaning of actuality. A man existent in fact is an actual man.

And what is man? He is a divinely created creature of animated flesh, made in the image of God.

Therefore, a divinely created creature of animated flesh made in the image of God and existent in fact is an actual man.

Scripture clearly teaches that man (so defined) is existent in fact (therefore actual) at the moment of conception. At conception man is called a zygote; at implantation, an embryo; at two months gestation, a fetus; at birth, a baby; at fifteen years, a juvenile; and at twenty-one years, an adult. Zygote, embryo, and fetus are mere descriptions of a man at different stages of his development. But throughout all of the developmental stages there is the basic continuity of *a man*.

Man, corporately and individually, is not the end product of a process in which an entity with potential to become a human being *acquires* such by degrees. Humanness is a *given* with much potentiality for positive development, through man's heartfelt submission to God's will, but also with much potentiality for negative suppression and distortion, through man's yielding to selfish desires in conflict with God's will.

Thus, when there is discussion about the abortion of a zygote-embryo-fetus, the talk really centers about an *actual* man with *potency* (the capability of developing in accordance with his given essence) rather than about a *potential* man (like an egg or sperm) with the possibility of becoming a man, but also without the inevitability of becoming such.

The Image of God and Man's Nature

The image of God in man indicates something about man's *nature* as well as his status. Because man is created in God's image, he has a unique constitution that is not like the constitution of the animals or of other living beings but, rather, like God's nature. Man has certain capacities (the capacity to love, to rule, to pray, and to think) that reflect what God is like.

Some theologians, however, thinking that "image of God" is to be defined *exclusively* in terms of a network of capacities in man, whether latent or expressed, have made the mistake of assuming that if a certain capacity is not ever present (such as the capacity to think as in the case of an anacephalic—one born without a cerebral cortex), then such a one is not image of God and is therefore not entitled to the full privileges of a divine image-bearer, such as the right to life under the protection of the sixth commandment ("Thou shalt not kill"). [4]

The problem with such thinking, which is ordinarily used to justify a "moderate" position on abortion, is that it

[4] John R. W. Stott, "Reverence for Human Life," *Christianity Today*, 9 June 1972.

has limited the meaning of the image of God in man to man's *nature* and has excluded the dimension of man's *status* (his unique relationship with God through which alone dignity and inviolability are conferred upon him by pure *agape* love and grace).

Furthermore, it must be noted again that the image of God (relative to man's status and nature) is not the end result of a process in which a nameless entity or product of conception acquires manness or humanness by degrees, until at birth it finally has sufficient manness or humanness to merit the protective diploma stating that it is now "image of God." Man's status and nature are both *givens*, and are not acquired somethings.

This is not to deny that man is in process. But what is added in the process is not more manness or humanness, but rather a progressively fuller development, expression, and extension of what in essence (by creation) is already present. The progression is not from part man (the fetus) to full man (the child after birth), but rather from full man to the full expression of man. Such progression does not end at birth but continues in one sense or another until the moment of death.

If it should become apparent that a certain unborn child is seriously deformed (perhaps lacking a cerebral cortex), that child's life cannot legitimately be taken by abortion or by encouraging it to die after it is born. The child's deformity is a result of the presence of original sin that has affected everything and everyone in the entire creation. Within man sin has, as it were, extensively damaged the image of God. But, however it is to be explained, Scripture clearly teaches that in a certain sense the image of God is partially retained in all fallen men (Adam and all his descendents, cf., Gen. 9:6; James 3:9; 1 Cor. 11:7). The anacephalic is no exception. And where there is the image of God, however minimal the remnants, there is a "child of God" and a "temple of the Holy Spirit," whose blood may not be shed.

It would be instructive, finally, to heed the advice of two eminent theologians who have struggled productively

39

with the question of the meaning and significance of the image of God in man:

> It is in connection with this act of creation [of man in the image of God] that Scripture refers to man's inviolable humanity, and earnestly proclaims that no one may offend against this humanity, and shows why this may not be done (Gen. 9:6, James 3:9). . . . Thus anyone who attacks his fellow man, or curses him violates the mysterious essence of man, not because man is . . . demigod, but because he is *man*. In all his relations and acts, he is never man-in-himself, but always man-in-relation, in relation to this history of God's deeds in creation, to this origin of an inalienable relation to his Creator. And this man is protected and maintained in his relation to God by Him.[5]

> . . . man cannot be known with a true and reliable knowledge if he is abstracted from this relation to God. Man would then be, from a scriptural viewpoint, nothing but an abstraction, and if we seek to define man merely in terms of various qualities and abilities, we are not giving a biblical picture of man. The criticism of the definition of man as "rational animal," or in some more subtle version of such a definition, is completely correct.[6]

Only through God does man attain his real dignity. There is no higher dignity and there is no greater inviolability than that of a child of God.[7]

> . . . it is by no means whatsoever because of man's immanent qualities that the "infinite accent" . . . falls upon him. His greatness rests solely on the fact that God in his incomprehensible goodness has bestowed his love upon

[5] G. C. Berkhouwer, *Man: The Image of God* (Grand Rapids: Wm. B. Eerdmans Publishing Co., 1962), p. 59.

[6] Ibid., p. 93.

[7] Helmut Thielicke, *Nihilism: Its Origin and Nature–With a Christian Answer* (New York: Harper & Row, Schocken Books, 1969), p. 108.

him. God does not love us because we are so valuable; we are so valuable because God loves us.[8]

In any case, because man—and along with him his world—acquires such alien, conferred dignity, he is inviolable. He is protected by the supreme patron. He is the apple of God's eye and dare not be touched. He was "bought with a price"; "Jesus Christ died for him" (Paul). He who touches him touches the supreme Majesty. He possesses this sacro-sanctity quite independently of his immanent qualities, and he possesses it not only in principle, by reason of his being a "human being," but also as an individual. Even if his life is "worthless" from a sociological point of view, even if he is completely "unproductive" and perhaps even represents a hampering burden who must be dragged along by the healthy, he is nevertheless the bearer of that alien dignity that delivers him from the throttling clutches of those who think only in economic terms and makes him the secret holder of an unapproachable majesty. In this sense the old hymn says, "To the weak He is kind."[9]

[8] Ibid., p. 110.
[9] Ibid., p. 112.

5

IS
ABORTION
MURDER?

Is abortion murder? At first it seems offensive even to ask the question. An adequate answer requires a brief review of what has been affirmed so far:

(1) That every man is of equal value without regard to his quality of life (intelligence, ability to produce, sociability, and desirability).

(2) That every man is unique and inviolate (which is the meaning of personhood) because of his special relationship to God as His image-bearer.

(3) That personhood begins at the moment of man's conception.

Three New Affirmations

Building on the above foundation, I also affirm it to be my judgment:

(1) That murder (intentional killing of an innocent human being because it is considered inferior and expendable rather than equally valuable and inviolable) of any human being at any stage

of its development from the point of conception to the point of death is morally wrong and should be subject to punishment meted out by duly constituted authorities.

(2) That all abortion (except critical abortion described below) is murder and is never permissible under any circumstances.

(3) That loss of life to the unborn that occurs as a result of an attempt to save the life of the mother when, on those rare occasions, it is reasonably certain that unless a critical abortion is performed both mother and child will die, is not murder.

"Thou shalt not kill." Certain scholars more knowledgeable in the original languages than I have said that the Hebrew word for "kill" (*rasach*) can better be translated "murder," and the New English Bible has so rendered Deuteronomy 5:17, "Thou shalt not murder." The word "kill" in and by itself carries no moral weight; neither does it speak to the humanness or nonhumanness of its object. In the sixth commandment God was really speaking about the deliberate destruction (inimical to the human community) of innocent human life without regard for its God-given absolute value and inviolability.

Four Ingredients of Murder

Therefore in thinking of abortion, I talk about the wrongness of murder. Four fundamental ingredients are identifiable in the definition of murder as I have given it:

(1) A person is killed.

(2) He is killed intentionally.

(3) The person killed is innocent.

(4) There is unlawful or sinful motive involved in the killing.

Such is murder. If any one of the four ingredients above is lacking in a particular killing, the killing is not necessarily murder. For example, it is not ever murder to butcher cattle for food. The death of a person caused accidentally by someone else is not ever murder. The intentional killing of

a person guilty of a capital offense is not necessarily murder, though (spiritually) it may be if there is hidden sinful motive that supercedes the explicit legal reason (lack of innocence). By religious standards the man who intentionally kills an innocent person, but not out of sinful motivation, is not morally guilty of murder though by the standards of the state he can still be so accused and prosecuted.

Abortion—and The Four Ingredients of Murder

What about abortion? Is it murder? Are all of the ingredients involved in murder present in an abortion? Consider:

(1) In abortion a human being is killed (see Chapters 3 and 4).

(2) In abortion the human being is killed intentionally, by an act of the will.

(3) In abortion the human being who is killed is innocent.

(4) In all abortion cases, except critical abortion, there is unlawful motive.

Points three and four above require further explanation.

It is argued by some that the unborn child is not innocent since its life is attacking the life of the mother. Dr. Joseph Fletcher in his *Situation Ethics*, commenting on the case of an insane patient raping and impregnating another insane patient, says of the conceived one: "The embryo is no more innocent, no less an aggressor or unwelcome intruder!"[1] But has a crime really been committed by the unborn child? The thoughts of David Granfield on this matter in *The Abortion Decision* are, as usual, incisive and to the point:

> A crime has two elements: a *mens rea*, or unlawful intention, and a *actus reus*, or unlawful conduct. Although the law does not punish *mens rea* alone, it may impose civil liability if there is an *actus reus* without *mens rea*, thereby sanctioning the actor for his unintended but

[1] Joseph Fletcher, *Situation Ethics* (Philadelphia: Westminster Press, 1966), p. 39.

45

unlawful conduct. An automobile fatality subjecting the driver to imprisonment if intended, may subject him only to tort damages if unintended, and even to no damages if he is excusable. The physical act was the same, but the responsibility in each case was radically different. [2]

The unborn child's conduct, on the other hand, is neither immoral nor criminal. No law requires the fetus to stop growing. Even if the child knew fully what was happening, he would find it impossible to control his normal and natural embryo-logical development. The child is doing what all children do.

It is not solely the lack of evil intention, an infantile *mens rea*, that makes the child innocent; it is primarily the lack of any evil deed, any even infantile *actus reus*. In total innocence, the child has an inviolable right to life. He forfeits this not by any principle of justice, but only by the principle of expediency. [3]

Another factor favoring the unborn child's innocence at the time of abortion is that the Fourteenth Amendment guarantees to every person the right of due process of law before its life can be taken away. Since the unborn child is a person, and since a person charged with a crime is innocent until proven guilty, and since abortion is done without due process of law, the aborted child is done a grave injustice.

But is it true that in all abortion cases, except critical abortion, there is unlawful (sinful) motivation involved? Yes. Take, for example, what might be the most difficult situation facing a woman and her doctor resulting in an abortion that would seem to be a killing not involving improper motivation: the case of a mother who was brutally raped. The mother has been deeply hurt; her emotions are frayed; her husband is resentful of the pregnancy

[2] David Granfield, *The Abortion Decision* (Garden City, N.Y.: Doubleday & Co., 1969), p. 141.

[3] Ibid., p. 142.

and wants no part of a "lunatic's seed"; the mother feels that she has been done a deep injustice. And she has! But by whom? Who is the guilty one? Who brought this upon her? The rapist. He is the one who should be sought out, prosecuted, and punished. The unborn child? What has he done? What can he do differently? Is he to suffer for the crime of the rapist? The mother, in her understandable frustration, diverts her hostility to her unborn. Irrationally she thinks she is "getting back" by having the child aborted. Maybe the child is innocent, she thinks in her more rational moments, but its life in this case is of less value than her life, and therefore it becomes expendable. The only possible rational reason for abortion following rape is the conclusion (value judgment) that the child's life is not equally as valuable as the mother's life and is not inviolate before the surgeon's hand.

What about critical abortion? Is this not murder, too? No. Loss of life to the unborn that occurs as a result of an attempt to save the life of the mother when, on those rare occasions, it is reasonably certain that unless a critical abortion is performed both mother and child will die, *is definitely not murder*. Why? Because even though an innocent human being is intentionally killed, there is no sinful motive involved necessarily.

(1) The motive is sinless in that the child is not killed as the result of a choice concerning the comparative value of two lives, but rather as the result of a choice to save the *only* life that can in this situation be saved.

(2) The motive is sinless in that the child is not killed as the result of a choice concerning its violability or inviolability, but rather as a result of the tragic circumstances having rendered all choice on that question meaningless (as for example in an ectopic pregnancy) and leaving as the only choice whether or not to save the *one* life that can possibly be saved.

If in fact a situation arises in which a very *real choice* has be made by the mother (the fetus not yet existentially

capable of choice) whether she will die so that her child may live or the child will die so that she may live, then, it would seem to me, that ideally the mother could be expected to respond in the same way that she would probably respond if that threatened child were three years old: by sacrificing her life, if the situation called for it, to save the life of her loved one. Has not such an act always been exalted by mankind as an exemplary expression of highest humanness? How many congressional medals of honor, awarded posthumously, have been awarded for heroic acts of self-sacrifice. Such morality, however, issues from the heart; it cannot be legislated and ought not be subject to punishment or condemnation if not fulfilled.

In summary, then, of the ideas expressed in this latest section, I again flatly state that all abortion (except critical) is murder. And if to some people the word "murder" sounds a bit harsh, then maybe the uneasiness this word causes them is due to a lack of understanding of what abortion is actually like. The picture is ugly.

Four Methods of Murder by Abortion

Abortion is the act whereby the unborn child is intentionally removed from its mother's womb and encouraged to die (as in a hysterotomy abortion), or is intentionally destroyed and then removed from the mother's womb (as in a dilatation and curettage abortion or a suction abortion), or is intentionally destroyed and then allowed to be stillborn by natural process (as in a salt poisoning abortion).

A more detailed description of the four methods of murder by abortion is as follows:[4]

(1) *Suction Abortion:* A tube attached to a powerful suction apparatus is inserted into the mother's uterus. The unborn child, with its placenta, is literally torn apart limb from limb and deposited in a jar as just so much fetal waste-material. Suction abortion is by far the most

[4] Cf. "Life or Death," a brochure published by Hiltz Publishin Co., 6304 Hamilton Ave., Cincinnati, Ohio 45224.

48

popular method of aborticide (accounting for about 75 percent of all abortions in the United States and Canada).

(2) *Dilatation and Curettage Abortion:* The word dilatation" refers to the forced enlargement of the cervix or neck of the uterus. The word "curettage" refers to the use of a curete (an instrument resembling a sharp-edged spoon) for scraping the so-called "products of conception" from the uterine cavity. As might be expected, the unborn child is cut to pieces by the surgeon's knife, and after removal, is reassembled by the operating nurse so as to make sure that no parts remain in the womb that might cause further bleeding or infection. This method may be used until the twelfth week, after which it is unsafe.

(3) *Salt Poisoning Abortion (Saline Amniocentesis):* It is generally considered unsafe to do an abortion between the twelfth and sixteenth weeks. After the sixteenth week enough fluid has accumulated in the amniotic sac to make it possible to inject either a 20 percent saline solution or a 50 percent glucose solution. The injection is made with a large needle through the abdominal and uterine walls, and the baby is poisoned to death within an hour's time. Anywhere from twenty-four to thirty-six hours later the mother goes into labor and delivers a dead baby which has the appearance of a candied apple because its skin has been burned off. This method of abortion ranks second behind suction abortion.

(4) *Caesarean Section Abortion (Hysterotomy):* This method of abortion becomes an available option after the unborn child has advanced beyond the fourteen-week stage. It is like a normal Caesarean section delivery in which the child is removed surgically through an incision made in the abdomen and uterus. But there is one difference: the child is not given the care it needs after its cord is cut; it is simply discarded in a stainless steel bowl and is heartlessly left to die—usually an asphyxial death.

Two Related Matters

Two other matters related to the question raised in this chapter still require attention.

First of all, for those who are interested in Scripture exegesis and try to base their thinking on biblical authority, the Exodus 21:22-25 passage often has come into the realm of discussion on the matter of murder. It reads:

> When men strive together, and hurt a woman with child, so that there is a miscarriage, *and yet no harm follows* [italics mine], the one who hurt her shall be fined, according as the woman's husband shall lay upon him; and he shall pay as the judges determine. *If any harm follows* [italics mine], then you shall give life for life, eye for eye, tooth for tooth, hand for hand, foot for foot, burn for burn, wound for wound, stripe for stripe.

The exegetical debate on these verses has focused on how the two "harms" mentioned in verses 22 and 23 are to be interpreted. Two contrasting positions with their conclusions are as follows:

(1) *Position A*[5]

> vs. 22: "and yet no harm follows"—The child is miscarried, but does not die.
>
> vs. 23: "If any harm follows"—The miscarried child and/or the mother dies.
>
> Conclusion: This passage does not place a higher value on the life of the mother over the life of her child, but requires "life for life" if harm (death) to either one or both occurs. If neither dies, a fine must still be paid because the woman has suffered emotional hurt in the forced premature birth of her child.

[5] Edwin H. Palmer, "Abortion: The Crucial Issue," a reprint available from Reformed Fellowship, Inc., P.O. Box 7383, Grand Rapids, Mich. 49510.

(2) *Position B* [6]

> vs. 22: "and yet no harm follows"—Even though the miscarried child dies, no harm is done because the mother has not died.
>
> vs. 23: "If any harm follows"—The mother dies as a result of the blow suffered by her.
>
> Conclusion: This passage suggests that death to the child is not a harm and does not come under the "life for life" principle, whereas death to the mother is a harm and comes under the "life for life" principle. Therefore, it seems that a higher value is placed on the mother's life and a lesser value on the life of her fetus.

My own views on Positions A and B above and on the Exodus 21:22-25 passage generally are as follows:

(1) If the interpretation of the two "harms" in Position A is correct, then its conclusion certainly follows.

(2) However, even though Position A might seem to be preferable, I am personally of the opinion that the interpretation of the two "harms" in Position B is a more likely interpretation because the focus of the whole passage is very definitely on the woman.

(3) But, even though I believe the interpretation of the two "harms" in Position B is correct, I do not believe that Position B's conclusion necessarily follows. Why?

(4) The reason why death to the fetus is *not* a harm but death to the mother *is* a harm has nothing to do with the relative value of the two lives. This most likely has to do with the lack of intentionality in the death of the child but the presence of intentionality in the death of the mother. It is nowhere explicitly stated in the passage whether the hurt suffered by the pregnant

Henry Stob, "Abortion: Yes or No?" *The Banner* 106, no. 23 (June 1971): 12. See also articles by Bruce Waltke and Kenneth Kantzer in *Birth Control and the Christian*, ed. W. Spitzer and C. Taylor (Wheaton, Ill.: Tyndale House, 1969), pp. 10-11, 553-554.

woman in the miscarriage was intentional or not. It is highly probable, however, that the attack upon her was intentional, because the principle of "life for life" did not apply in Mosaic law to a death *accidentally* caused. If the pregnant woman were a mere by-stander or by-passer and was accidentally struck by a wild blow, then the Mosaic law would not require "life for life"; it would require something less (like a fine) for life. In verse 14 of the same chapter the law reads: "But if a man *willfully* [italics mine] attacks another to kill him treacherously, you shall take him from my altar, that he may die." Deuteronomy 19:4-10 actually states that three cities were to be set apart for the protection of people who were involved in accidental manslaughter and were being pursued by hateful avengers.

(5) A likely reconstruction of the incident would be something like this: Two men were fighting. The pregnant wife of one of the two men interfered on her husband's behalf (A dead or injured husband isn't much help when another child comes along). The other man intentionally struck her (it was two against one). The woman was hurt and suffered a miscarriage. The assailant, by law, had to pay a fine if the hurt he caused to the woman did not result in injury or death (no harm followed). But if the hurt he caused resulted in injury or death (harm followed), the assailant had to pay with his eye, tooth, hand, foot, burn, wound, stripe, or with his life. The miscarried child's ultimate state (dead or alive) was immaterial because what happened to it was purely accidental.

(6) Evidently, it was so common an occurrence for a wife to interfere in her husband's brawls that a special clause of "fair play in fighting" had to be introduced into the Mosaic law, because sometimes the wife became a bit too vicious. In Deuteronomy 25:11 the law reads: "When men fight one another, and the wife of the one draws near to rescue her husband from the hand of him who is beating him, and puts out her hand and seizes him by the private parts, then you

shall cut off her hand; your eyes shall have no pity."

(7) I would not for a minute contend that a biblical case for saying that the unborn child is of equal value and that the intentional killing of it is murder can be based on an argument from silence, as in Exodus 21:22-25 where nothing is said about what might have happened to the assailant if he had *intentionally struck the child in utero* causing it to die (which would have been an abortion rather than a miscarriage). But neither can a wrong conclusion about the lesser value of the unborn child, based on this passage (Position B's conclusion), be used as a possible biblical justification for abortion.

Capital Punishment and War

The second matter related to the question about murder, which can be appropriately discussed, concerns the validity of capital punishment and war. If abortion is murder, some ask, then what about capital punishment and war?

Again we must assess which of the four ingredients of murder are or are not present in capital punishment and war:

(1) In capital punishment and war *human beings are killed.*

(2) In capital punishment and war human beings are killed *intentionally.*

(3) In capital punishment and war, however, the human beings killed are *not innocent—* provided, of course, they are proven guilty and sentenced to death by a court of law (as in capital punishment) or are proven guilty and declared war upon by an act of congress (as in the case of a just war).

(4) *Unlawful (sinful) motive is not necessarily involved* in capital punishment and war:

 (a) The victim is not necessarily considered inferior, but guilty before the bar of justice and therefore punishable for the sake of justice.

 (b) The victim is not necessarily considered violate or expendable. Theoretically at least, the

person doing the killing is (as a delegated functionary of the state) fulfilling representatively the wrath of God (Rom. 12:9—13:7) and thus is not killing as man *qua* individual man (which would be murder) but as man *qua* representative of God (which is not murder because man is not inviolate before God).

6

AN APOLOGY FOR THE NECESSITY OF LEGISLATING MORALITY

A familiar red flag commonly raised against those who are seeking to preserve or reinstate strict abortion laws is that they have no right to impose their morality on other people—especially on people who question the personal status of the unborn child and who do not regard all persons as worthy of equal esteem. In this regard two sections of a statement distributed recently by the Mountain States Women's Abortion Coalition are illustrative:

> The claim that the fetus is a person does not come from science; this idea can only be based on philosophical opinion.

> While . . . the anti-abortion forces have the right to hold the belief that the fetus is a person, and to conduct their reproductive lives accordingly, they have no right to impose this philosophical belief on everyone else in the United States.[1]

From a handbill distributed by the Mountain States Women's Abortion Coalition.

What have we here? One group (pro-life) is told by another (pro-abortion) that they *ought not* (because they have no right to) impose their beliefs on other people if those beliefs are based in philosophy but have no basis in science. Interesting! What might be said in response?

Quite apart from the fact that the personal identity of the unborn child, as previously shown, does have some basis in science as well as in philosophy and theology, the claim that only moral beliefs based in scientific facts may receive the privileged status of moral *oughts binding on all people* is preposterous. In what scientific fact is this belief about beliefs based? Is not this belief itself based in a particular philosophical viewpoint? And *who* says that I *ought not* impose my beliefs on others? Precisely those who say this are imposing their own ought upon me.

I am reminded of a statement in Steinbeck's *East of Eden* that represents the same *philosophical* viewpoint:

> This I believe: that the free, exploring mind of the individual human is the most valuable thing in the world. And this I would fight for: the freedom of the mind to take any direction it wishes, undirected. And this I would fight against: any idea, religion, or government which limits or destroys the individual. This is what I am and what I am about.[2]

If I might venture a personal reaction to the viewpoint expressed above, I would say that I, likewise, do not wish to unnecessarily limit or destroy the individual; I, too, would oppose any idea, government, or religion that would attempt to do so.

But if someone should say to me that it is wrong for me to hold a *particular* idea, religion, or government to the exclusion of other particular ideas, religions, or governments because such particular and exclusive ideas, religions, and governments destroy the freedom of the individual, then would have to say that I believe this man's idea is wrong and inherently contradictory.

[2] John Steinbeck, *East of Eden*, chapter 13.

Who is right? If the other man says that I am wrong, then he has limited me and has thus disqualified his own idea about ideas.

If he says I am right, then he has disproved his own idea about ideas because his idea is antithetical to mine.

If he says that we are both right because all ideas, regardless of whether or not they are logically contradictory, are acceptable, then I must ask him: "What is going to be your reaction when I tell you that the particular idea I have in mind with regard to you is one that will be personally threatening to you? Suppose I tell you that I have an idea that I must measure your value in terms of how well you function. Therefore since you are sixty-five years old and a detriment to society (by my standards), I have decided to physically dispose of you."

He might respond by saying: "Ah, but such an idea with regard to me proves the destructiveness of entertaining particular ideas to the exclusion of other ideas!"

To which I would have to say: "The problem is not with my *idea*, nor with the *particularity* of my idea. The problem is that my particular idea is a *wrong* idea; but there is to it a corresponding *right* idea, namely, that I should love you as myself. I would not do away with myself for reasons of failure to meet the adequacy criteria of others; neither should I do away with you for such reasons."

Is it not true, after all, that freedom construed as open-ended opportunity to do whatever one may wish is in actuality not freedom at all, but enslavement to a kind of arbitrariness that inevitably impinges on the freedom of other men—even their right to life?

Does not my freedom to swing my arm end at the tip of another man's nose? Does not my freedom to determine my own morality relative to my body, my reproductive practices, and my personal privacy end at the exact point that such rights begin to impinge destructively on the rights of *another person*?

Another example of the destructive, philosophically based mentality that pervades the ego-centric pro-

abortion movement came to me as I listened to an attorney from Washington D.C., lecture on "Morals" at a World Affairs Conference at the University of Colorado. Morals, he affirmed, are a good thing, even though they don't *really* exist. They are a form of public speaking: a discussion of the outward aspects of the deeper inner meanings of behavior. It is good to talk about outward behavior, but not to insist that such public discussion should in any way determine or change what each individual from within himself decides to do or not to do. Morals ought not to interfere with behavior.

Each individual must learn, according to the attorney, to consult his instinct (his inherent mechanism of sex) again. He must look within himself to his own built-in censor and search no further for an ultimate appeal by which to justify his behavior. What he does he should decide to do according to his own instinctual standards, not on the basis of what others say. Not to look within the self and consult the instinct is to denigrate one's own personality and lose oneself as an individual.

As I listened to this attorney speak, some questions arose: Why is he using a forum of public discussion to tell me that I *must* learn to consult my instinct again when, within his framework of thought, it is illegitimate to base any "ought" on such discussion?

And another question insisted on an answer: Why is this man an *attorney at law*? Laws have to do with telling people what is right and wrong. How can this man tell me that I am my own god who needs to consult only my own instinct in moral decision-making, and then turn around and tell me, by his very identity as an attorney, that he has a right to insist that the standards of a moral society apply to me?

In a sense I want to agree with the attorney. Morals ought not in and by themselves determine the mores (behavior patterns) of people. But morals do not exist in a vacuum. Morality does not just happen.

What does happen is that people behave in certain ways because they make *judgments* about that behavior in terms

of some *standards* they embrace, to which standards they attach the term *morals*. Behind the morals are *principles*, which are in turn based upon an ultimate *ground,* or reality.

Regardless of what the attorney said and regardless of what he may in the future do in his ambiguous position of functioning as an attorney, it is nevertheless a fact that his behavior, like the behavior of everyone else, is governed by a standard that is in turn based upon a principle that is in turn based upon a particular view of reality. In the attorney's case, ultimate reality seems to be nature or physical energy; the locus of moral value (principle) is feeling or awakened instinct; the standard (moral) is to do whatever feels good; the behavior pattern (mores) is a life lived in obedience to the above standard.

And yet, despite what the attorney *thinks,* does he not *act* or function as an attorney at law because he recognizes that not all men are naturalists (or perhaps that not all naturalists are rational, which introduces still another standard) and that he must therefore resort to law as a means whereby to enforce his ethic upon others?

The same ambiguity apparent in the philosophy and life of this attorney is manifest in the thinking and actions of many pro-abortionists. They raise stringent objections against those who are seeking to preserve or reinstate abortion laws because, they claim, such laws are an imposition of morality. And they are! But are not the civil rights laws passed in the sixties and fought for by many people in the pro-abortion movement today also impositions of morality? Yet who would deny that an imposition of morality to protect a black man from a white red-neck lyncher is legitimate and necessary?

Morality must be imposed when the actions of one person impinge on the personal welfare of another. Such is clearly the case in abortion. Abortion laws are indeed both legitimate and necessary.

I conclude this argument for the necessity of an imposed morality with a short story.

Once upon a time man decided that there was no God. And all metaphysical inquiry ceased. So some men looked to the natural order (which was all there was left to look to) and said: "Nature is absolute." And the world of scientific facts had sole freedom in the city, though a haunting awareness of a deeper, ultimate reality remained. But then, from close behind them, they heard the voices of other men saying: "We are absolute." And then each man began crying: "I am absolute." And then there was war. And the justification was law, based on consensus. But in the end there was God. And His way was peace because men could agree, by looking to Him, about what was love and how it ought to be shown. And His justification—Himself, for He was the beginning as well.

7

GROUNDS FOR ABORTION—ARE THERE ANY?

There are no grounds, no societally sanctioned values, no mitigating circumstances that justify abortion of any kind, other than critical abortion to save the mother's life when the lives of both mother and child are genuinely threatened. This is not to deny that certain pregnancies create severe problems for the parents, society, and the child. But such problems demand the creative, constructive, and compassionate attention of all people.

Abortion solves no problems ultimately; it only makes situations seem better for a time. Since abortion is destructive of innocent people and dehumanizing to the destroyers, it ultimately comes back to haunt society with many disturbing side effects, not the least of which is the tendency of an increasingly large number of people to solve their problems through eliminating other people.

A frustrated teen-ager can indeed decide to "solve" his problem of getting along with a domineering, cantanker-

ous father by simply killing him. But what has he solved? Even if society should be of such a mind as not to punish children who kill their undesirable parents, what has the young teen-ager gained? Freedom *from* his domineering father? Yes. But *for* what is the son now free? To develop a completely selfish life-style that sometimes results in the elimination of people whenever they cross him wrongly. But what kind of freedom is that? It sounds more like tyranny.

The hypothetical example of a son killing his father sounds far-fetched, but it validly illustrates the point that whenever any one man is granted the freedom to murder persons as a legitimate way of solving deep personal, family, or societal problems, then all men become slaves. Abortion is the subtle harbinger of a most terrible tyranny.

In this light we must consider some of the legitimate-sounding grounds for abortion that have become the basis for the liberalizing or eliminating of abortion laws by many legislatures and courts today.[1]

The Eugenic Ground

Without question one of the most significant revolutions astir in our time is in the biological field. Through the advances brought about in the biological sciences, it has become possible to detect various kinds of fetal defects (such as Downs syndrome, or "Mongolism") and to make forecast of physical or mental deformity.

Fetal defects that result in physical or mental deformity arise from either a genetic source (faulty genes or abnormal distribution of chromosomes) or an environmental source (viral infections like rubella or drugs like thalidomide).

In states where the American Law Institute (ALI)

[1] It must, of course, be remembered that all of the state laws referred to in this chapter have been superceded by the January 22, 1973, United States Supreme Court Rulings in the Texas and Georgia cases. Nevertheless, since the states are still being given some say-so on abortion after the third month of pregnancy, this discussion on grounds for abortion and what the states previously have decided remains relevant.

guidelines on the termination of pregnancy by abortion are followed (Colorado being the first state to adopt these guidelines and to liberalize its abortion law, in 1967), the reasonable certainty of a predicted serious deformity becomes a ground for abortion. Such might be called *forecastive abortion*.

Forecastive abortion raises many questions:

(1) How much certainty must there be? The chance of deformity to a child whose mother has been exposed to the rubella virus during the first four weeks of pregnancy is about 60 percent. The chance after six weeks drops to 30 percent and after eight weeks to 10 percent. Colorado law, which permits abortion until the baby has reached term (except in a rape or incest case), would allow an abortion even when the chances are one in ten. So, is it right that nine normal children be destroyed to prevent the birth of one deformed child?

(2) How serious must the defect be? Colorado law says: "Grave and permanent." What is that? Who decides? By what standard? The lack of two arms is permanent, but is it grave? The lack of eyesight is seemingly grave by some standards, but is it necessarily permanent, in view of cornea transplants? A low intelligence quotient may be permanent, but by what standard is it grave? By the standard of the parent's unwillingness to accept and care for such a child? By the standard of what it may cost the state if it should have to assume responsibility? By the standard of what I.Q. may have to do with happiness, if anything? By the standard of the child's eventual usefulness to society? But if mercy and compassion are qualities to be cultivated in society, would society learn such qualities if it set on a course of eliminating all "weak ones"? Or was Nietzsche perhaps right when he said that the highest good is the rule of the strong (self-assertion, pride, and determination) and the chief evil is any protection of the weak (meekness, gentleness, and love)?

(3) If the child *in utero* surrenders its right to life because of an expert prediction that its *post partum* condition will be one of retardation, mental or physical, does the child who is one year old and suddenly afflicted with a debilitating disease that will eventually cause it grave and permanent deformity also surrender thereby its right to life?

(4) What kind of twisted logic is it to suggest that a child with a fetal defect is being done a favor to be aborted because it has a right to be born normal? In a pamphlet prepared by the Colorado Right to Life Committee, entitled "Abortion: To Maintain the Quality of Life," Dr. Watson Bowes, Jr. says:

> When the diagnosis is made prior to birth there are only two alternatives: birth with the appropriate care and support of an inevitably retarded or deformed human being or abortion with the elimination of the affected individual. It is this stark paucity of choices that gives the lie to the apparently altruistic demands that each man has the right to be born with normal body or mind. This argument would be profoundly persuasive if the choice were between being born with an abnormal body or being born with a normal body. But it becomes absurd to discuss the right of the individual to be normal when the alternative is not being an individual at all. *The choice is between being abnormal or being destroyed.*[2]

In the *Saturday Review of Science* (5 August 1972) John V. Tunney and Meldon E. Levine discuss the whole matter of "Genetic Engineering" in an article by that title. Ten *ethical* questions are suggested in the article that serve to pinpoint some of the complexities of engaging in any eugenics. Though some of the questions bring us slightly astray of the present subject of abortion on eugenic grounds, I think it would be helpful to quote the essential parts of all ten

[2] This brochure can be obtained from the Colorado Right To Life Committee, P.O. Box 20144, Denver, Colo. 80220.

questions anyway, if for no other reason than to show the broader context of ethical discussion related at least indirectly to abortion.

First, if we are to engage in any eugenics, negative or positive, we must confront three vital questions that pervade this entire subject: What traits are to be considered desirable? Who is to make that determination? When in the course of human development will the choice be made?

. . . Second, we must ask whether the genetic engineering or "improvement" of man would affect the degree of diversity among men. Does it presume a concept of "optimum" man? Is diversity important as a goal in itself? Does—or should—man seek a "unique"? What would the quest for an "optimum" do for our sense of tolerance of the imperfect? Is "tolerance" a value to be cherished?

Third, . . . do different ethical considerations apply if we attempt to distinguish between experimentation on an unfertilized sperm or egg, a fertilized sperm or egg, a fetus, an infant, a child, or an adult?

. . . Fourth, is there a workable difference between, on the one hand, genetic "therapy" to correct genetic factors known to cause somatic disease and, on the other hand, genetic "engineering," defined as techniques to alter man in terms of some parameters other than somatic disease?

. . . Fifth, . . . it should be asked whether techniques developed for the therapy of an individual patient automatically diffuse into the general public for purposes other than this therapy. Are physicians operationally capable of restricting the use to one group, or does societal pressure make them semiautomatic dispensers of seemingly desirable technologies?

Sixth, we might ask whether any eugenics program—whether positive or negative, voluntary or compulsory—does not imply a certain

attitude toward "normalcy," toward a proper norm for human activity and behavior, and toward expectations with regard to the behavior of future generations of human beings. Implicit in this question are distinctions with regard to positive versus negative eugenics programs and also with regard to compulsory versus voluntary eugenics programs.

Seventh, how are words such as "normal," "abnormal," "health," "disease," and "improvement" defined? Are they words that can be operationally used to determine what should be done in the area of genetic engineering?

Eighth, we must ask if the quest for genetic improvement would be continuous. Would it invariably make all children "superior" to their parents? What would be the social consequences of this? Would it institutionalize generation gaps and isolate communities by generations?

Ninth, we should consider whether the institutionalization of a quest for genetic improvement of man is likely to lead to his perception of himself as lacking any worth in the state in which he is. What does this do to the concept of the dignity of the human being in his or her own right, regardless of some "index of performance"?

Tenth, if we have a well-developed ability to perform genetic therapy as an assault upon certain diseases but such therapy is not available for all who have the affliction or who desire the "cure," the question will immediately arise as to how to determine which patients will receive it. Are some classes or groups of people more desirable patients or more worthy of treatment? How will selection be made? By what criteria will those decisions be reached?[3]

The Humanitarian Ground

An *altruistic abortion,* may it be called, is permitted by many legal statutes when the mother's pregnancy

[3] John V. Tunney and Meldon E. Levine, "Genetic Engineering," *Saturday Review of Science* 55, no. 32 (August 1972): 24-26.

has resulted from rape or incest. Women's liberationists and abortion coalitionists would have the humanitarian ground broadened to sustain altruistic abortions on behalf of the unwanted child as well. They assert:

(1) Altruistic abortion on behalf of the mother victimized by *rape or incest.*

It may seem, initially, on the basis of an immediate emotional response to a rape resulting in a pregnancy, that the mother has suffered such an indignity that she should (by the demands of love) be entitled to relief from the responsibility of carrying a rapist's child. Such thinking has tremendous emotional appeal and is entirely understandable. But when the *demands of love* conflict with the *demands of justice* (which is love distributed fairly to all persons), then love for the mother which allows her to kill her unborn child is really not love at all—at least not in the more comprehensive sense of justice. It is not loving to give another person the license to commit a murder so as to cure a rape. The demands of love extend to the innocent unborn child, too! And so the just (comprehensively loving) response to rape is not to liberalize abortion laws, but to enforce stricter laws against rape, seek more diligently to apprehend the rapacious offender, provide more societal assistance to the burdened mother, and allow the unborn child to live and eventually be loved by the immediate parent or by adoptive parents.

Quite apart from the fact that an extremely low percentage of rape cases result in pregnancy, it remains true anyway that a person's right to life ought never to be made conditional upon how the person *began.* The basic moral question in both rape and incest is not: Is this child a result of a sex crime? but rather: Is this child image of God, person?

(2) Altruistic abortion on behalf of the child victimized by being thrust into a situation of being *unwanted.*

The rhetoric of the liberationists trumpeting the right of the child to be born wanted is as misleading as it is trite. If it were possible for the unborn child to choose to be wanted or unwanted, the child would predictably and rightfully choose to be wanted. But if the alternative to being wanted is being eliminated, what kind of choice is *that*? Since the child cannot even make the choice (fruitless though it would be, considering the alternatives), there are those who make its choice for it by killing it, and then piously pretending that their killing is really not an act of murder but of mercy because it is done as a humanitarian favor to the child. This is a favor? All living unwanted persons in society had better hope that aspiring power elitists do not get the idea to do them a similar favor. Of course, there is a name for all of this altruistic nonsense—it is called "prenatal euthanasia" (Willke) or gracious killing of unborn children.

In my view, one of the most moving statements in the Willke's *Handbook on Abortion* speaks to this problem of the unwanted child:

> We agree that every child should be wanted. A world without unwanted children would be an idyllic place in which to live. No one could quarrel with that as an idealistic goal. Wouldn't it also be a wonderful world if there were no unwanted wives by husbands, no unwanted aging parents by their children, no unwanted Jews, Black People, Catholics, Chicanos, or ever again a person who at one time or place finds himself unwanted or persecuted. Let's all try to achieve this, but also remember that people have clay feet and sadly, the unwanted will always be with us.

> The measure of our humanity is not that there aren't unwanted ones, but what we do with them. Shall we care for them or kill them?[4]

[4] Dr. and Mrs. J. C. Willke, *Handbook on Abortion*, rev. ed. of January 1972 (Cincinnati: Hiltz Publishing Co., 1971), pp. 46-47.

The Psychiatric Ground

Therapeutic abortion on psychiatric grounds accounts for the vast majority of abortions performed today. For example, in the state of Colorado in 1971, "maternal mental health" was listed as the medical ground for 3,889 of 4,168 abortions. In 1972, in Colorado, 93 percent of reported abortions were for "maternal mental health." Purportedly, therapeutic abortion is required in some cases because of an immanent threat of suicide or because of the likely result of serious permanent impairment of the mental health of the woman.

Based on the reading I have done and on my own counseling experiences, I would question, factually, whether pregnancy does increase the threat of suicide, and would wonder whether abortion is not a greater contributor than it is a preventor of serious psychic disturbances within the women who have had abortions.

Four personal counseling experiences are illustrative:

(1) *Counselee A:* A man whose pregnant wife had committed suicide after suffering serious mental disturbance.

This man reported to me that his wife had been experiencing mental problems for some time. In the midst of her problems she discovered that she was pregnant and at first was ecstatically happy. But soon she became depressed again and continued in that condition until one day she called the hospital and made an appointment for an abortion. The night before her scheduled abortion, she took her own life.

The husband recalled in retrospect that what had prompted his wife's suicide was the decision in her mind to "do away" with her unborn. The mere fact of giving in to the idea of an abortion was enough to take away her last incentive for living.

The experience of Counselee A's wife is not atypical, but matches the facts.

For 16 years (1950-65), Dr. Alex Barno did a study on suicide in Minnesota that included

1,301,745 women with normal pregnancies (about 80,000 live births per year). Comparing males, pregnant females, and nonpregnant females, the study showed that the least number of suicides occurred among the pregnant females (0.6 per 100,000 average) as compared to 3.5 per 100,000 average among the nonpregnant females and 16 per 100,000 average among the males.

Many psychiatrists now believe that the risk of suicide for women who have had abortions is much greater than for women who have not had abortions.

The Colorado Right to Life Committee's *Newsletter* of October 1972, quotes an associate professor of psychiatry at UCLA, Dr. Pietro Castelnuovo Tedesco (from R. Kotulak's *Emotional Myths That Cloud the Issue*), as saying:

> In the past psychiatrists would testify that a woman would probably commit suicide if she didn't get an abortion. Such testimony was required in order to perform a therapeutic abortion under the old laws. We were fudging in behalf of the patient for humanitarian reasons. It may have been for a good cause, but it was still fudging on psychiatric standards and on scientific truthfulness.[5]

(2) *Counselee B:* A girl who had had two abortions, the first legally, the second illegally.

> This girl reported to me that even though she had had no previous social conditioning on the wrongness of abortion, and even though she held no strong religious convictions of any kind, she felt that the second abortion had literally scraped the last vestiges of her own *human-ness* away and had left her with a totally empty self—not just an empty womb but an empty being: devoid of self-respect and a reason to live. This total sense of emptiness or alienation drove her to drugs and, but for the grace of God, to suicide.

[5] Colorado Right To Life Committee, *Newsletter* 2, no. 10, p. 3.

Quite frankly, I believe this girl's experience illustrates that whether men acknowledge God or not, all men experience an inner reproach (not always consciously felt) when they depart from the ways clearly revealed by God as right.

Dr. Paul Tournier, Swiss physician and author of several excellent books, says in *Guilt and Grace:*

> Thus the true guilt of men comes from the things with which they are reproached by God in their innermost hearts. Only they can discover what these things are. And they are usually very different from the things with which they are reproached by men. The reference to God brought to us by the Bible illuminates our problem in a remarkable way: from now on, "false guilt" is that which comes as a result of the judgments and suggestions of men. "True guilt" is that which results from divine judgment. In fact, the guilt towards oneself of the Jung School is indeed at the same time a guilt towards God, since it is a refusal to accept oneself as God wishes us to be; and the guilt towards others of Martin Buber is also a guilt towards God since it is a refusal of the divine order of human relationships.[6]

What kind of concern for the mother's mental health is it that would exclude considerations of the guilt problems that most women have *after* abortion?

(3) *Counselee C:* A girl who had two previous abortions and had just tried and failed to induce a third by running up a steep hill. This girl was pregnant unintentionally with a Hell's Angel while her husband was incarcerated in the state prison.

I asked this girl why she wanted another abortion. She replied that her husband was incensed about her pregnancy through another man and would not rejoin her after his release

[6] Paul Tournier, *Guilt and Grace* (New York: Harper & Row, 1962), p. 67.

from prison if she did not do something to get rid of the baby. I then asked how she felt about the other two abortions. She responded that she was guilt-ridden, though she couldn't explain why since she had no religious faith of any kind and did not believe in a God at all, nor ever had.

In thinking of this poor girl now, I wonder: If guilt is purely a "learned reaction," then why did this waif of the world experience an inner censorship that she could not shake?

(4) *Counselee D:* A girl who had had a suction abortion and was invited by her doctor to view the "fetal remains" in a jar.

This particular girl reported that she "felt nothing" when she viewed the torn-up aborted child. She claimed she felt no guilt whatsoever. In fact what bothered her was precisely the *absence* of any guilt feeling. The numbness and hardness of her spirit, for which she had gradually conditioned herself, scared her and made her feel "one" with the "butchers at Buchenwald" who could view heaps of dead bodies in mass graves and not "feel a thing."

Dr. Julius Fogel, a gynecologist-obstetrician who advocates therapeutic abortions and performs them, and who is also a Freudian psychiatrist, has said:

> Mental illness does not automatically follow an abortion. Often the trauma may sink into the unconscious and never surface in a woman's lifetime. But it is not as harmless and casual an event as many in the pro-abortion crowd insist. A psychological price is paid. I can't say exactly what. It may be alienation, it may be pushing away from human warmth, perhaps a hardening of the maternal instinct. Something happens on the deeper levels of a woman's consciousness when she destroys a pregnancy. I know that as a psychiatrist (From *Unseen Scars Left By Abortion*, by Colman Mc Carthy).[7]

[7] Colorado Right To Life Committee, *Newsletter* 2, no. 10, p. 3.

Socio-Economic Ground

If *demographic abortion* is to be allowed to solve the problems of the parents who "can't support another kid" in the microcosmic sphere of the home, and to solve the problems of society that "can't stand to have any more people because too many people cause crowding and pollution" in the macrocosmic sphere of the whole earth, then why not extend this same principle further and eliminate a whole lot of other undesirable people so as to solve the socio-economic problems faster and more effectively?

Is it right to kill *persons* to solve such problems? Unborn children are persons too. What does it take to make men see that people cause problems (like poverty and pollution) not because they *exist* but because of how they *think*. This world has a better chance of survival if put in the hands of the projected aborted ones than if kept in the hands of those trying to play the dangerous game of God, giving and taking life.

Legal Ground

In speaking of a legal ground, I am referring to the mother's claim that she is being deprived of her rights over her own body and over her privacy when she is denied an abortion on demand.

If the demand for *personal abortion* on legal grounds were not mentioned so often by women's liberationists particularly, it would not be worth the time of day to comment on it.

Aside from the incontrovertible fact that the unborn child is not part of the mother (biologically, genetically, or spiritually as an independent image-bearer), it can also be stated that the mother's right over her own body is not *absolute*, so that even if the unborn child were a part of the mother's body, she would have no right to authorize a doctor to dispose of it. If a woman asked a surgeon to amputate a perfectly healthy leg, and the surgeon did it, he could be sued by a third party for malpractice. Doctors may remove cancerous tumors, cysts, and the like, but the

73

zygote-embryo-fetus is not an unnatural intruder in the body of its mother; it is a rightful occupant in the womb introduced into its nine-month home by an act of sexual intercourse that took place quite apart from its own willful involvement.

As to the pregnant woman's privacy, no one would want to interfere with it, unless her privacy became a cloak for violence perpetrated against her own children. If I, for example, began to beat unmercifully my four-year-old son, to the point of death, I might expect that if his cries were loud enough, the police would promptly interrupt my privacy and rescue my child if possible.

Sad to say, the unborn child has no voice and his cry is not heard, except by those (and sometimes they seem so few) who listen with the ears of their hearts and try to save its life, not often successfully.

8

THE SOCIAL PROBLEM
OF THE
WOMAN

Because of their specialized concern for the unborn child, pro-life forces are particularly vulnerable to the charge that, in their efforts to humanize the unborn child, they only succeed in dehumanizing women.

As this book has deliberately focused on the "person-status" of the unborn child and the implications of personhood for that child, it, too, may be liable in the reader's mind to the same accusation of unconcern for women who, in being denied abortion as an alternative, may face terrific social problems of one kind or another.

The social problems faced by many pregnant women admittedly are great. There may be economic, physical, or emotional stresses. The child may be illegitimate. Social pressures might be a factor, as for example when an unmarried pregnant mother wants to complete her education or when her parents push for an abortion because they want to avoid a public disgrace. But illegitimacy is not a *disease*; it is a *social* problem of the mother. She may think that the presence of an unborn child within her is the

apparent cause of her distress and that therefore its elimination is the easiest apparent solution.

But each mother considering an abortion must honestly ask herself this question: Is it *ever* valid for one person with a social problem to kill another person who, by his mere *presence*, appears to be the cause of that social problem? If, for example, two people are starving because they have to share a food supply that is barely sufficient to keep one person alive, is it valid for the one starving person to solve his social problem by killing the other starving person? The second starving person is not guilty of improper motivation or conduct. He is simply there, and his presence causes a problem. But the same is true the other way around. So who is to kill whom? Or is killing not the answer?

Society solves many of its social problems by punishing people who cause these problems. But the guilt of such wrong-doers *must* involve unlawful intention and conduct. The mere fact that a man exists in a situation where his existence (his being there) creates a social problem for other people does not justify classifying him as a criminal offender in any sense!

What would happen if society began to define the criminal in terms of his beingness and the circumstances of such, rather than in terms of his behavior? And yet, have not the liberalized abortion laws set a dangerous precedent in that direction? Who may be sure that other laws dealing with other social problems will not be solved in the exact same manner? And when that happens, who is really safe? The *reductio ad absurdum* of such thinking might, by a certain logic, lead certain governments of this world to solve their population problems by dropping hydrogen bombs on other nations of people who, by their existence, put a strain on the welfare of the rest of humanity. Woe be to the nation or individual who is on the light end of the balance-scale of power in that kind of new world!

When pro-life forces channel great energies and resources into fighting the philosophy of problem-solving as

described above, they are in fact manifesting a direct concern for the mother. If women are permitted to have abortions to solve their social problems, but in the process they introduce to public acceptance a philosophy of problem-solving that will eventually come back to haunt and threaten them, then what have they gained? Is it not true concern to try to stop a woman who has chosen a course of action that will eventually destroy her?

In the New Testament letter of Paul to the Romans, these words are found:

> Let love be genuine; hate what is evil, hold
> fast to what is good; love one another with
> brotherly affection; outdo one another in show-
> ing honor (Romans 12:9, 10).

This scriptural gem sets love in proper perspective. On the one hand, it rules out a kind of *sentimentality* that is so concerned not to hurt someone that it refuses to interfere with or censor anything another person may or may not do. True love, by contrast, is sometimes expressed both in hatred of evil and approval of good; it is directive; it says: "No, don't go in that destructive direction;" or, "Yes, that kind of behavior will ultimately be fulfilling for you."

On the other hand, true love rules out a kind of *harsh condemnatory spirit* that is so dead set against evil that its animosity against evil is transferred to the transgressor as well. True love hates evil but loves the evil-doer. A clear example is that of conscientious parents who discipline their delinquent children, but do so because they are deeply concerned about their children's future welfare.

It is incredibly difficult to resist the extremes of sentimentality or judgmentalness. But such is the high calling of love. It is difficult for social workers counseling women with problem pregnancies to look beyond the symptoms, beyond the immediate social problems of the women, and consider the causes and the more difficult, constructive solutions. Likewise is it difficult for pro-life advocates to bear in mind the immediate social problems of women with problem pregnancies even while they attack the

deeper dimensions of the problem relating to the unborn child and to the dehumanization of man. But love demands no less.

In discussing the social problem of women in this matter of abortion, the aspect of guilt must not be lightly dismissed. Many women claim that they suffer no guilt pangs from the experience of having had an abortion. This may or may not be true. There is no way of proving it one way or the other. But many other women, by their own admission, *do* have guilt problems that cause them much mental distress. This distress may take the shape of self-hatred, over-protection of the other children, a growing inability to be touched by the infirmities of others, thoughts of suicide, confusion on other moral issues stemming from previous compromise, and many other shapes.

Mental health definitely has a spiritual dimension. Guilt feelings are caused when people violate the laws of God and bring about a disjuncture between themselves and their Creator. If such alienation is actually felt by the guilty person (and it *is* real whether felt or not,) it is felt only because the guilty person still has some sensitivity to the moral laws of God written on every man's heart. But if the senseless mind of the guilty person becomes too hardened through rationalization, suppression, and repeated transgression, then that person may claim that he isn't receiving any guilt messages. But spiritual numbness to the point of not feeling any guilt in killing one's own unborn child is a dangerous state of mind because it is self-destructive. The problem, always, with not loving one's neighbor as one's self is that in the end the self is less loved.

Is it not an act of loving concern to gently help women considering abortion to see that in having an abortion they will run a grave risk of laboring the rest of their lives under the lead weight of persistent guilt feelings?

There is another way in which the efforts of pro-life advocates can ideally be seen as acts of concern for women with problem pregnancies. That way has to do with an idea expressed earlier about what it is that is most fulfilling to a

person. I believe that the self-hood (humanness) of man is most fulfilled when the self is given away or extended to the neighbor in responsible and loving acts and decisions. Some would call this the suicide of self. I would call it the birth of independence. Jesus said: "For whoever would save his life will lose it, and whoever loses his life for my sake will find it" (Matt. 16:25). And elsewhere He said: ". . . . but whoever would be great among you must be your servant, and whoever would be first among you must be your slave; even as the Son of man came not to be served but to serve, and to give his life as a ransom for many" (Matt. 20:26b-28). Paul said: "Do nothing from selfishness or conceit, but in humility count others better than yourselves. Let each of you look not only to his own interests, but also to the interest of others" (Phil. 2:3, 4).

No person can, of course, be forced to embrace the self-denying attitude toward life as expressed above. Unconditional love and mercy cannot be forced. But the kind of environment that is conducive to such an unselfish attitude can be insisted upon and legislated to a degree. People who are prevented by law from the willful and arbitrary killing of their unborn children will often be sensitized by such a "legalism" to the deeper levels of human responsibility as it pertains to love and concern for others. In this sense the law becomes a custodian until grace comes (cf. Gal. 2:23, 24); it is a guide to righteousness in that it keeps before men's eyes the ugly reality of their sin (cf. Rom. 3:20)

Today, the emphasis seems to center on the pursuit of personal happiness rather than on a desire to reach out and fulfill other persons. Marriage and childbearing have become subsidiary means to the higher goal of existing for personal pleasure. If happiness is threatened in a marriage or by a pregnancy, then the marriage or pregnancy must be terminated. Nothing may be permitted to stand in the way of happiness. No institution, no unwanted child, no human responsibility is so precious that it cannot be expediently offered to the supreme god of this insidious happiness cult.

But there is something in all of this happiness-seeking that is little understood. Happiness is a coy mistress. She flees when sought, and appears out of nowhere when she is least expected. Viktor Frankl, the founder of "Logotherapy" and Professor of Psychiatry and Neurology at the University of Vienna, had this to say on happiness and self-actualization:

> Whereas, if this normal reaching out for meaning and beings is discarded and replaced by the will to pleasure or the "pursuit of happiness," happiness falters and collapses; in other words, happiness must ensue as a side-effect of meaning-fulfilment. And that is why it cannot be "pursued," because the more we pay attention to happiness, the more we make pleasure the target of our intentions by way of what I call hyperintention, to the same extent we become victims of hyper-reflection. That is to say, the more attention we pay to happiness or pleasure, the more we block its attainment, and lose sight of the primary reason of our endeavours; happiness vanishes, because we are intending it, and pursuing it. This makes it impossible for fulfilment to ensue. . . .

> Now what holds for pleasure and happiness also holds for self-actualisation. Self-actualisation is a good thing; however, we can actualise ourselves only to the extent to which we have fulfilled a meaning, or encountered another human being. But we have no longer any basis for self-actualisation at the moment we are striving directly for it.[1]

So far I have not said much about how the *immediate* social problems of women with problem pregnancies should be approached. In this connection, I refer to the work being done by an organization called *Birthright* as an

[1] Viktor E. Frankl, "Nothing But—," a paper presented to an interdisciplinary conference of scientists in Alpback, Austria organized by Arthur Koestler. The proceedings of the conference have been published under the title *Beyond Reductionism—New Perspectives in the Life Sciences* (New York: Macmillan Co., 1968).

illustration of what pro-life people can do and are doing to work constructively on this side of the problem.

Birthright is an organization of trained volunteers concerned to serve women who have unplanned or unwanted pregnancies. It was begun by Louise Summerhill in Canada, but has spread to the United States, where many chapters are being formed in cities by people motivated by a reverence for life and a deep concern for expectant mothers.

Birthright helps by offering emotional and practical support on a one-to-one basis, as well as offering a referral service. The *Birthright* volunteer tries to be a concerned and loving friend to the woman who calls the *Birthright* office with a problem. She also tries to help in practical ways by getting whatever medical, psychological, or financial help the mother may need to see her way through the period of distress. To accomplish this, *Birthright* has resources that include physicians, psychiatrists, social workers, and clergymen, in addition to many others in the community who offer their services and support to pregnant women.

On an even more practical level, *Birthright* offers free pregnancy tests, free emergency housing and transportation, and used maternity and baby clothes.

Under no circumstances will *Birthright* ever advise or refer for abortion. It seeks instead to offer only positive assistance and to encourage the mother to accept responsibility toward the sacred and precious life she carries within her. *Birthright's* statement of purpose succinctly illustrates its vision:

> To uphold, promote, counsel and preserve the sacredness of human life from the moment of conception and at all times thereafter.
>
> To render aid, counseling and assistance to expectant mothers, married or unmarried, regardless of age, quality, condition, race, religion, creed, color or nationality during all phases of pregnancy, for the benefit, health and well-being of both the mother and her unborn child and to render such aid, counseling and

assistance subsequent to the birth of the child as will be in the best interests of both mother and child; and to work in cooperation with persons, associations and agencies, public and private, on a non-sectarian, interdenominational and nonpartisan basis, in providing the expectant mother with assistance consistent with the purposes stated above, and with rules, regulations and statutes relative to the practice of Law or Medicine or other laws enacted for the protection of children.[2]

It would seem only right that churches, too (especially those which have issued strong statements regarding the evils of abortion), should feel a moral constraint to lend their full spiritual resources to women with problem pregnancies. This help may come in the form of pastoral counseling, financial aid directly to the mother who cannot afford a delivery, political pressure for more just adoption procedures, financial and prayer support for institutions of mercy like adoption agencies, hospitals, and mental health centers, or just in the form of people who care enough to "follow through" with those parents who make the hard decision to have their baby. I believe, incidentally, that such matters are part of the special responsibility of the church's diaconate.

Efforts to humanize the unborn child ought never to result in dehumanizing women. Hopefully, it has been shown that such efforts need not have such a result, though in some cases, unfortunately, it has happened.

[2] Used by permission of Denver Birthright, Inc., 1001 Jasmine St., Denver, Colo. 80220.

9

AN INFAMOUS DAY IN AMERICAN HISTORY

On January 22, 1973, the Supreme Court of the United States decided by a seven to two vote that, in Justice Blackmun's words, the term "person" as it is used in the Constitution, *"has application only postnatally"* (italics mine). The Associated Press story quotes him as saying further:

> We need not resolve the difficult question of when life begins. When those trained in the respective disciplines of medicine, philosophy and theology are unable to arrive at any consensus, the judiciary, at this point in the development of man's knowledge, is not in a position to speculate as to the answers.[1]

So now we have abortion on demand nationwide by Supreme Court decision. After the third month the states may, if they choose, put on limited regulations related to maternal health. For all practical purposes, however, the die has been cast for the unborn.

[1] Associated Press release as published in the January 22, 1973, edition (page 1) of the *Boulder Daily Camera*.

Justice Blackmun and the six others who voted with him in what may be the most infamous Supreme Court decision in American history (outranking in infamy even the Dred Scott decision of March 6, 1857, which defined the Negro slave as "property" rather than "person") have either not done their homework, or are so caught up in the irrationality of the times that they cannot see the real issue. Nor can he and the others see, it would appear, the frightening nihilistic implications of their decision.

Yes, there has been a lack of consensus among the various disciplines. But not on the question of when *life* begins! Even the most avid pro-abortionists agree that *life* (indeed, *human* life) begins at conception. The point of disagreement has centered around the question of when *full status of humanity or personhood* begins. On this very question where there has been *real* difference of opinion, the seven "sovereign" justices have made up their minds (and supposedly, the minds of everyone) that in the Constitution the term "person" "has application only postnatally." So only after the child is *born* does it receive full status of humanity or personhood. Before that time it is a helpless and voiceless pawn of the whims of the mother who has been influenced by the climate of opinion created by the Court's decision and perhaps has actually come to believe, selfishly, that the rights over her body and privacy are absolute; it is a pawn of the whims of the states that may or may not decide to put some controls on abortion after the first three months, which controls will not amount to much more probably than making sure that the clinical facilities are adequate.

The game of playing god is getting more dangerous every day in this morally bankrupt and ill-fated society. The power elitists have spoken again. Who will be next to have the price tag on his life lowered because he has not attained or *retained* full status of humanity? How soon will the day come when the Court will tell us that although the term "person" "has application only postnatally," it does not necessarily apply in *every case* of childbirth because

some human progeny lack sufficient qualities (sufficient intelligence, ability to produce, sociability, or desirability) that they have decided to use as criteria for their *definition* of personhood?

And will that be the day when they tell us that it is for the benefit of society as a whole to have the state mercifully kill such human entities?

If it should for a moment be granted that *in the Constitution* the term "person" "has application only post-natally," then it should become a matter of utmost concern to the wide majority of people in this nation who do not favor abortion—because they believe that the value of every human being is absolute—to encourage their congressman to provide and submit to the states a new amendment to the Constitution stating that the full status of personhood necessary to receive the protection of the Fourteenth Amendment begins at conception.

It took a Civil War and almost ten years to undo the Dred Scott decision through the Fourteenth Amendment passed on June 13, 1866. What will it take to undo this latest decision? How many millions of innocent lives will have to be slaughtered this time?

Many hearts are weeping today in desperate anticipation of the mass funeral for the aborted children and for those who have and will commit moral suicide in the blind destruction of their own human offspring, and subsequently of their own *humanness*.

It may be too late for this nation of peoples. The red-hot sun of a new quality-of-life ethic has dawned long before this day, and it is scorching the spirit of man, slowly reducing him to a self-obsessed automaton of social utility.

The Court has decided, and it seems that the power elitists have prevailed. But what is *legal* is not necessarily *moral*. There remain millions of people, born and unborn, who need unselfish care and unconditional love. To such ends all those who have fought abortion must continue to live their lives.

APPENDIX:

TWO LITURGICAL READINGS FOR HUMAN LIFE SUNDAY

A Service of Worship 89

he Least of These My Brethren 101

A SERVICE
OF WORSHIP

In Praise to God: For Life First Given

THE VOICE:

> Creator of life and enemy of death,
> I lift up mine eyes, as the poet saith,
> to offer thee praise,
> Great Giver of Days!

THE WORD:

> "In the beginning God created the heavens and the earth." [1]

THE VOICE:

> In the beginning!
> In the beginning . . . God!
> In the beginning God . . . created . . . ME!

THE WORD:

> "And God said, 'Let us make man in our own image, after our
> .eness. . . .' So God created man in his own image, in the image of
> .od he created him; male and female he created them." [2]

THE VOICE:

> From beginning to beginning
> I was there in God's plan,

Genesis 1:1
Genesis 1:26a, 27

always in God's mind:
inviolable man.

THE WORD:

"Now the word of the Lord came to me saying, 'Before I formed you in the womb I knew you, and before you were born I consecrated you. . . .' " [3]

THE VOICE:

"For thou didst form my inward parts,
thou didst knit me together in my mother's womb.
I praise thee, for thou art fearful and wonderful.
Wonderful are thy works!
Thou knowest me right well;
my frame was not hidden from thee,
when I was being made in secret,
intricately wrought in the depths of the earth.
Thy eyes beheld my unformed substance;
in thy book were written, every one of them,
the days that were formed for me,
when as yet there was none of them." [4]

THE WORD:

"Then the Lord God said, 'It is not good that man should be alone; will make him a helper fit for him. . . .' So the Lord God caused a dee sleep to fall upon the man, and while he slept took one of his ribs. . . and the rib which the Lord God had taken from the man he made into woman and brought her to the man. . . . Therefore a man leaves h father and his mother and cleaves to his wife and they become on flesh." [5]

"And God blessed them, and God said to them, 'Be fruitful ar multiply, and fill the earth and subdue it. . . .' " [6]

THE VOICE:

"For this child I prayed;
and the Lord has granted my petition
which I made to him.
Therefore I have lent him to the Lord;
as long as he lives,
he is lent to the Lord." [7]

3. Jeremiah 1:4, 5
4. Psalm 139:13-16
5. Genesis 2:18, 21, 22, 24
6. Genesis 1:28a
7. I Samuel 1:27, 28

THE WORD:

"And they were bringing children to him, that he might touch them; and the disciples rebuked them. But when Jesus saw it he was indignant, and said to them, 'Let the children come to me, do not hinder them; for to such belongs the kingdom of God. . . .' And he took them in his arms and blessed them, laying his hands upon them." [8]

THE VOICE:

"Lo, children are a great reward,
a gift from God in very truth;
with arrows is his quiver stored
who joys in children of his youth." [9]

THE WORD:

"And God saw everything that he had made, and behold, it was very good." [10]

THE VOICE:

Innocence is like a child
asleep in dinner chair
with glass of milk in outstretched hand, while
loss of same is like a man, awake,
staggering through life down ulcerous path,
unable for slightest moment to break his step
lest crystal cup of life's investments
fall-slip from clutching hand
and shatter then in lustful dream of better things. [11]

In Repentance to God:
For Life Then Taken

THE WORD:

"Now the serpent was more subtle than any other wild creature that the Lord God had made. He said to the woman, 'Did God say, "You shall not eat of any tree of the garden"? ' " [12]

"So when the woman saw that the tree was good for food, and that it was a delight to the eyes, and that the tree was to be desired to make one wise, she took of its fruit and ate; and she also gave to her husband, and he ate." [13]

Mark 10:13, 14, 16
Versification of Psalm 127:3-5a by Lowell Thomas
. Genesis 1:31a
. Poem: "Innocence"
. Genesis 3:1
. Genesis 3:6

THE VOICE:

> God
> my crutch,
> my buttress is
> to bear me up
> when I,
> like Adam, fall.
>
> Adam fell when
> a dame fell in
> a damn fall down.
> God condescends
> to pick me up;
> but once
> I'm up,
> I then prefer
> the serpent's hand.
>
> That is, until
> again I fall;
> then posit God
> I must,
> a brace
> for my support.
>
> I need a God,
> of course,
> or not so much
> perhaps
> as what
> He gives. [14]

THE WORD:

"The Lord God said to the serpent, 'Because you have done this. . .
will put enmity between you and the woman, and between your se
and her seed. . . .'" [15]

"And when they were in the field, Cain rose against his brother Ab
and killed him." [16]

"The Lord God saw that the wickedness of man was great in the ear
and that every imagination of the thoughts of his heart was only e
continually." [17]

14. Poem: "Limping Along with God"
15. Genesis 3:14a, 15a
16. Genesis 4:8b
17. Genesis 6:5

"Then Herod, when he saw that he had been tricked by the wise men, was in a furious rage, and he sent and killed all the male children in Bethlehem and in all that region who were two years old or under. . . . Then was fulfilled what was spoken by the Prophet Jeremiah:

> 'A voice was heard in Ramah,
> wailing and loud lamentation,
> Rachel weeping for her children;
> she refused to be consoled,
> because they were no more' " [18]

"[And Jesus said:] Alas for those who are with child and for those who give suck in those days." [19]

"And because wickedness is multiplied, most men's love will grow cold." [20]

THE VOICE:

> I am the man of cold desire:
> I am my own enemy.
> My life is determined, measured
> by the selfish I.
> Would to God I could forget,
> forget myself,
> only to find myself lost;
> a lostness expressing itself in finding others,
> others other than things,
> others existing apart from me:
> sensitive others,
> beautiful others,
> others to be known,
> others to be loved.
>
> Oh, that I could live!

THE WORD:

"You shall not kill." [21]

"Do not envy a man of violence and do not choose any of his ways; for the perverse man is an abomination to the Lord, but the upright are in his confidence." [22]

18. Matthew 2:16a, 17, 18
19. Luke 21: 23a
20. Matthew 24:12
21. Exodus 20:13
22. Proverbs 3:31, 32

"Lie not in wait as wicked man against the dwelling of the righteous; do no violence to his home." [23]

"When men strive together, and hurt a woman with child, so that there is a miscarriage, and yet no harm follows, the one who hurt her shall be fined, according as the woman's husband shall lay upon him; and he shall pay as the judges determine. If any harm follows, then you shall give life for life, eye for eye, tooth for tooth, hand for hand, foot for foot, burn for burn, wound for wound, stripe for stripe." [24]

"There shall not be found among you any one who burns his son or his daughter as an offering. . . ." [25]

"At that time the disciples came to Jesus, saying, 'Who is the greatest in the kingdom of heaven?' And calling to him a child, he put him in the midst of them, and said, 'Truly, I say to you, unless you turn and become like children, you will never enter the kingdom of heaven.' " [26]

"Rescue those who are being taken away to death; hold back those who are stumbling to the slaughter." [27]

"Then they also will answer, 'Lord, when did we see thee hungry or thirsty or a stranger or naked or sick or in prison, and did not minister to thee?' Then he will answer them, 'Truly, I say to you, as you did it not to one of the least of these you did it not to me.' " [28]

THE VOICE:

> I am the man of death and of violence:
> I am the man of joyless despair.
> Show me the joy
> in a meaningless battlefield,
> in the napalm-pitted face of a Vietnamese,
> in the awesome threat of nuclear devastation,
> in the irrational outbreak of racial riot.
> Show me the joy
> in a murdered fetus,
> in a sex-abused, bewildered child,
> in a rebellious, psychopathic teen-ager,
> in a self-destructive, tormented college student,
> in a helpless, homosexual adult.
> Show me the joy
> in a desperate society
> addicted to an over-consumption of drugs,

23. Proverbs 24:15
24. Exodus 21:22-25
25. Deuteronomy 18:10a
26. Matthew 18:1-3
27. Proverbs 24:11
28. Matthew 25:44, 45

plagued by thousands of annual suicides,
grieved by countless automobile accidents,
devastated by tornadoes, earthquakes, and floods,
threatened by cancer, heart attack, and death.
Death wrenches from life its meaning;
life has no lasting significance.
I have no love, only desire.
I have no courage, only fear.
I have no joy, only despair.

Oh, that I could live!

THE WORD:

"Repent therefore, and turn again, that your sins may be blotted out, that times of refreshing may come from the presence of the Lord, and that he may send the Christ appointed for you, Jesus." [29]

THE VOICE:

"Have mercy on me, O God, according to thy steadfast love; according to thy abundant mercy blot out my transgressions. Wash me thoroughly from my iniquity, and cleanse me from my sin! . . . Against thee, thee only, have I sinned, and done that which is evil in thy sight, so that thou art justified in thy sentence and blameless in thy judgment. . . .Deliver me from blood-guiltiness, O God, thou God of my salvation, and my tongue will sing aloud of thy deliverance." [30]

In Commitment to God:
For Life Once Restored

THE WORD:

"Comfort, comfort my people, says your God. . . . Behold, the Lord God comes with might, and his arm rules for him; behold, his reward is with him, and his recompense before him. He will feed his flock like a shepherd, he will carry the lambs in his arms, he will carry them in his bosom, and gently lead those that are with young."[31]

THE VOICE:

O Christ of comfort,
I drop my guard
and let your words
bombard my heart.

Still heat my snow-hung heart;
spring rain my reasoned mind;
come solve my crystal soul.

29. Acts 3:19, 20
30. Psalm 51:1, 2, 4, 14
31. Isaiah 40: 1a, 10, 11

I follow you down the road of your suffering
and hope to tread but far enough to reach the cross
where I can see the One who died
that I myself might live.

THE WORD:

"In the beginning was the Word,
and the Word was with God,
and the Word was God.
He was in the beginning with God;
all things were made through him,
and without him was not anything made
that was made.
In him was life,
and the life was the light of men. [32]

"For as the Father has life in himself,
so he has granted the Son
also to have life in himself." [33]

"Do not labor for the food which perishes,
but for the food which endures to eternal life,
which the Son of man will give to you." [34]

"Jesus said to her,
'I am the resurrection
and the life;
he who believes in me,
though he die,
yet shall he live.' " [35]

"Jesus said to him,
'I am the way,
and the truth,
and the life.' " [36]

"And this is the testimony,
that God gave us eternal life,
and this life is in his Son.
He who has the Son has life;
He who has not the Son of God
has not life." [37]

" . . . God shows his love for us

32. John 1:1-4
33. John 5:26
34. John 6:27
35. John 11:25
36. John 14:6
37. I John 5:11, 12

in that while we were yet sinners
Christ died for us." [38]

"But God raised him up,
having loosed the pangs of death,
because it was not possible
for him to be held by it." [39]

"For we know that Christ
being raised from the dead
will never die again;
death no longer has dominion over him.
The death he died
he died to sin,
once for all,
but the life he lives
he lives to God.
So you also must consider yourselves
dead to sin and alive to God
in Christ Jesus." [40]

"For as in Adam all die,
so also in Christ
shall all be made alive.
But each in his own order:
Christ the first fruits,
then at his coming
those who belong to Christ.
Then comes the end." [41]

"Therefore . . . let us run with perseverance
the race that is set before us,
looking to Jesus the pioneer
and perfecter of our faith,
who for the joy that was set before him
endured the cross,
despising the shame,
and is seated at the right hand
of the throne of God." [42]

THE VOICE:

"Gracious is the Lord, and righteous;

38. Romans 5:8
39. Acts 2:24
40. Romans 6:9-11
41. I Corinthians 15:22-24a
42. Hebrews 12:1b, 2

our God is merciful.
The Lord preserves the simple;
when I was brought low, he saved me.
Return, O my soul, to your rest;
for the Lord has dealt bountifully with you.

For thou hast delivered my soul from death,
my eyes from tears,
my feet from stumbling;
I walk before the Lord
in the land of the living." [43]

In Gratitude to God:
For Life Now Fulfilled

THE WORD:

"Bless the Lord, O my soul;
and all that is within me,
bless his holy name!
Bless the Lord, O my soul,
and forget not all his benefits,
who forgives all your iniquity,
who heals all your diseases,
who redeems your life from the Pit,
who crowns you with steadfast love and mercy,
who satisfies you with good as long as you live
so that your youth is renewed like the eagle's." [44]

THE VOICE:

O God of precipitate grace,
I ask that as your love swells the channel of my life
it may irrigate my heart with gratitude,
make fertile the fallow desert of my mind
and sprout mercy from the planting of my hands.

The Psalmist claims to bless you every day
and to praise your name for ever and ever.
It would be simple dishonesty on my part
to even pretend that I am so continually grateful.
Just as I forget the existence of the sun
because I cannot gaze for long into its brilliance,
so, too, do I forget your divine goodness
because I cannot gaze for long at your majestic splendor.
But not only am I unable;

43. Psalm 116:5-9
44. Psalm 103: 1-5

the problem is with my will.
And so, O God, I ask for pardon, first of all,
lest my hurried cries of praise
sound like the beating of a hollow drum for rain.

Thank you, divine practitioner, for health impregnable,
in spite of which I dare resent the slight advance
 of a common cold,
never considering the violent pain, multiplied one hundredfold,
endured by those whose guts are raped,
and whose brains are seduced,
and whose hearts are ravished
 by the side-effects of sin.
For celibate colon unspotted by cancer,
for delicate brain unembraced by tumors,
for virginal heart unmolested by clots,
I thank you, O immaculate God of grace.

Thank you, too, for a place to lodge awhile.
I need but envision the shifting, war-winded masses
blown about like sand-grains over human deserts,
and I realize that having an oasis called home
is a most elemental, earthy blessing.
I thank you, then, for a place to recover
when my strength is evaporated,
and I need home's springs,
when my mind is parched,
and I need home's draught,
when my body is drained,
and I need home's fill.

Thinking of home reminds me of my family,
for which I also give thanks, O God of all grace.
Just to hear my baby cry when it is time for a bottle,
to hear my child giggle when she rides piggy on my back,
to see my child's expression at the sight of a new doll,
to feel the warmth of my child's breath
as she sleeps on my neck—
and to know that this child is mine—
such joys I cannot describe!
And when I sit down next to that person I love, my wife,
and detect with a sensitive, searching finger
the soft lines of her tired, yet beautiful face;
and when I probe the captivating depths of her adoring eyes
and see there an affectionate devotion for me
so strong that it cannot but force its way to the surface
and bubble up out of her eyes,

then I am left speechless;
such joys I cannot describe,
and I almost choke as I once again
give thanks to you, O God of all grace,
for this unspeakable, unimaginable gift.

Praise be to you, O God, for the beauties of each new day,
beauties which play upon the lute strings of my heart
and make me want to sing:
"This is the day that the Lord has made;
I will rejoice and be glad in it!"
If this day be hot, I will love the sun
for it beams healing on my light-starved body;
if this day be dark, I will love the rain
for it drops freshness to my reasoned mind;
if this day be wild, I will love the wind
for it stirs life in my stagnant spirit;
if this day be cold, I will love the snow
for it sprays whiteness on my scarlet soul.

I need not go to the concert hall
to hear the beautiful strains of symphonic music.
Just to hear the rustle of the wind through the leaves,
the melody of the birds chirping softly in the trees above,
and the splattering sound of the rain against the window pane,
is enough for me to know that all of nature sings,
and if I but listen I can hear it.

Praise be to you, O God,
for the colorful tapestry of the clouded skies,
for the majestic grandeur of the snow-capped mountains,
for trees and rocks and animals and dirt,
for sun and moon and stars and planets,
for heavens which tell of your glory,
and for a firmament which proclaims your handiwork.
Let heaven and nature sing, and I will listen.

O God of precipitate grace,
I ask that as your love swells the channel of my life
it may irrigate my heart with gratitude,
make fertile the fallow desert of my mind
and sprout mercy from the planting of my hands. [45]

Amen!

THE WORD:

Amen!

45. Poem: "Therapy of Thanksgiving"

100

ONE OF THE LEAST
OF THESE MY BRETHREN

At a moment in time, at the beginning of time,
and yet a moment beyond time
God in His infinite, unselfish love said:
"Let us make man in our image, after our likeness." [1]

"O Lord, thou hast searched me and known me!
For thou didst form my inward parts,
thou didst knit me together in my mother's womb.
I praise thee, for thou art fearful and wonderful.
Wonderful are thy works!
Thou knowest me right well;
my frame was not hidden from thee,
when I was being made in secret,
intricately wrought in the depths of the earth.
Thy eyes beheld my unformed substance;
in thy book were written, every one of them,
the days that were formed for me,
when as yet there was none of them." [2]

"So God created man in his own image,
in the image of God he created him;
male and female he created them."[3]

1. Genesis 1:26
2. Psalm 139:1, 13-16
3. Genesis 1:27

Male and female, a unity in a diversity,
like the God who is one in three!
Male and female, a diversity in a unity,
like the God who is three in one!

And man, in the likeness of God's creativity, knew his wife,
in the likeness of God's creativity; and she conceived and
bore a little one, a child in the image of father and mother,
a unique person in the fellowship of dependency, mutual love,
and responsibility.

Blessed is he, for mercy is his,
who cheerfully uncoils the heart-cords of fellowship
securing his brother (and brothers each other)
from stumbling to certain destruction—
the face of life's mountain of such steep complexion
that without the security of a fellow companion
death's canyon would crush him, in surety. [4]

God gave man a mind and a will by which to perceive and choose
the way of love and service in this fellowship of caring
persons. But man's sensitive mind became hardened in prideful
rebellion against God.

"For although they knew God,
they did not honor him as God
or give thanks to him,
but they became futile in their thinking
and their senseless minds were darkened.
Claiming to be wise, they became fools. . . ." [5]

"Therefore God gave them up in the lusts of their hearts
to impurity, to the dishonoring of their bodies
among themselves,
because they exchanged the truth about God for a lie
and worshiped and served the creature
rather than the Creator who is blessed forever!" [6]

"And since they did not see fit to acknowledge God,
God gave them up to a base mind and to improper conduct.
They were filled with all manner of wickedness,
evil, covetousness, malice.
Full of envy, murder, strife, deceit, malignity. . . ." [7]

4. Poem: "Beatitude"
5. Romans 1:21, 22
6. Romans 1:24, 25
7. Romans 1:28, 29

The mind of man out of phase with the mind of God
puts the heart of man out of phase with the soul of his brother,
for when man measures himself by the infinite,
he sees that his brother, though dependent,
is equal and inviolable.
But when man measures himself by the finite,
he reckons that his brother, because dependent,
is inferior and expendable.

And so the undesirables, lacking sufficient quality of life
to compete in the marketplace of human price-tagging,
are sold cheaply to the butchers of humanity:
because they are too old to be consuming the vital resources,
too black to be human enough for liberty,
too retarded to be free from the insane whims
of the expert manipulators playing I.Q. roulette,
too criminal to be ever rehabilitated,
and too much children to be unconditionally wanted
and given their right to be born.

But he that is of men most sovereign
is he that stands to men the farthing
when they, and he, unconsciously,
think up or down in speaking.

He that is of men the Master
is he that stands to men the servant
when they, and he, subconsciously,
think up or down in working.

He that is of men most honored
is he that lost for men his glory
when he, for them, quite consciously,
went down to shame in dying.

"Through him we have obtained access
to this grace in which we stand,
and we rejoice in our hope of sharing the glory of God.
More than that, we rejoice in our sufferings,
knowing that suffering produces endurance,
and endurance produces character,
and character produces hope,
and hope does not disappoint us,
because God's love has been poured into our hearts. . . ." [8]

". . .God shows his love for us

8. Romans 5:2-5

in that while we were yet sinners Christ died for us." [9]

Planted
by faith
in the soil of His death,
I swell in brown gloom
of hope's greener stem
awaiting Light's key
to penetrate tomb
and draw me out free,
fresh flower, gay color
of love
openly. [10]

"See what love the Father has given us,
that we should be called children of God;
and so we are." [11]

"By this it may be seen who are the children of God,
and who are the children of the devil:
whoever does not do right is not of God,
nor he who does not love his brother." [12]

My emotions were stranded on an island of thinking
when, suddenly, by just my whisper of greeting,
I found myself drinking your refreshing presence
when you answered me: "Come, my brother."

These words seemed to spill from your innermost being,
not as a tide of usual social babbling,
but as though your being were a sea-cup of love
most easily tipped by my breezy "hello." [13]

"For this is the message which you have heard from the beginning,
that we should love one another,
and not be like Cain who was of the evil one
and murdered his brother.
And why did he murder him?
Because his own deeds were evil and his brother's righteous.
Do not wonder, brethren, that the world hates you.
We know that we have passed out of death into life,
because we love the brethren.

9. Romans 5:8
10. Poem: "Resurrection"
11. I John 3:1
12. I John 3:10
13. Poem: "I Said Hello"

He who does not love remains in death.
Any one who hates his brother is a murderer,
and you know that no murderer has eternal life
abiding in him.
By this we know love,
that he laid down his life for us;
and we ought to lay down our lives for the brethren." [14]

Love is
the silent grandeur of suffering long
and perpetually waiting,
not trampling on
while others trip on treacherous bait
it too has known.

Love is with the meek untiringly,
with those who drain its breast of kindness
and produce of itself,
yet never ask the fulness dry
of more than it can give.

Love is not zealous much nor jealous to protect in subtle greed
its private rights of body and sense
which it would have us think
apply in every circumstance.

Love has no rights so absolute.

No right of way has love
on the narrow ledges
where men do traffic
in search for lasting answers
they hope to find across the gaps
which prostrate love has spanned.

Love can tally consciously
the good which people do it,
but when the counting shows
an offense on the sheet,
love's mind is quick to strike the key
subtracting bad from memory.

Love does not gleefully pounce
on weaker creatures who've slipped
in moral faults they faint could see;
it stoops instead most willingly

14. I John 3:11-16

to hoist the maimed and fearful victims
on its crooked back.

Love is like a cranial roof
which covers the mistakes of others
and patiently endures
when these same wrongs, discerned without,
weigh heavily in criticism
on its own head.

Love accepts a man because he's there
and thereby worthy of living fare.

Love presumes in man such gold supply
as a smile's worth of trust can buy.

Love stands its ground
with more than passive resignation
because it has triumphant sense to know that it will surely pass
the test to human fortitude
which it has stood so long. [15]

"When the Son of man comes in his glory,
and all the angels with him,
then he will sit on his glorious throne.
Before him will be gathered all the nations,
and he will separate them one from another
as a shepherd separates the sheep from the goats,
and he will place the sheep at his right hand,
but the goats at the left.

Then the King will say to those at his right hand,
'Come, O blessed of my Father, inherit the kingdom
prepared for you from the foundation of the world;
for I was hungry and you gave me food,
I was thirsty and you gave me drink,
I was a stranger and you welcomed me,
I was naked and you clothed me,
I was sick and you visited me,
I was in prison and you came to me.'

Then the righteous will answer him,
'Lord, when did we see thee hungry and feed thee,
or thirsty and give thee drink?

15. Taken from the poem: "A More Excellent Way"

And when did we see thee a stranger and welcome thee,
or naked and clothe thee:
And when did we see thee sick or in prison and visit thee?"
And the King will answer them,
'Truly, I say to you,
as you did it to one of the least of these my brethren,
you did it to me."' [16]

16. Matthew 25:31-40

INDEX

Abortion,
 definition of, 48
 grounds for,
 eugenic, 62-66
 humanitarian, 66-68
 legal, 73, 74
 psychiatric, 69-72
 socio-economic, 73
 methods of,
 Caesarean section (hysterotomy), 20 48, 49
 dilatation and curettage, 48, 49
 saline amniocentesis, 48, 49
 suction, 48, 49
 types of,
 altruistic, 66-68
 critical, 44, 45, 46, 47, 48, 61
 demographic, 73
 forecastive, 63, 64
 personal, 73, 74
 therapeutic, 69-72
Abortion on demand, ix, 21, 73, 83, 84
Absolute value, x, 6, 7, 85
Actual, definition of, 36
Agape, 10, 11, 12, 39, 40, 41, 77
Alaska, state of, 21
Alexander, Dr. Leo, 8, 9

American College of Obstetrics and Gynecology, 20, 24
American Law Institute, ix, 62, 63
Amniotic fluid, 18, 27, 49
Amniotic sac, 18, 49
Anacephalic, 38, 39
Animal contrasted with man, 31, 36, 38
Apathy, x, 85
Arbitrary freedom, 57, 62

Barno, Dr. Alex, 69, 70
Berkhouwer, G. C., 40
Birthright, 80-82
Blackmun (Justice), 83, 84
Body, man as, 31, 34, 35
Bowes, Dr. Watson, Jr., 64
Brain activity, fetal, 23, 25, 27
Breath, breathing, 19, 20, 27, 31, 33, 34, 36
Buber, Martin, 71

Canada, 18, 49, 81
Capacities of man, 38, 39
Cerebral cortex, 26, 38, 39
Cervic, 18, 49
Chromosomal pattern, 18, 24, 25, 27, 35
Colorado, state of, ix, 21, 63, 69
Conception, moment of, 24, 25
Conception of Jesus, 33
Crime, definition of, 45, 46

Dehumanization, 24, 61, 75, 77, 78, 82, 85
Dependence vs. independence, 18, 19
Development, fetal, 25-28
Divorce, 12, 13, 79
Downs syndrome, 62
Dred Scott decision, 84, 85
Dualism, 33, 34, 35

Ectopic pregnancy, 47
Ensoulment, 33, 34, 36
Eros, 10, 11, 12
Eros consciousness, 12, 13
Euthanasia, 6, 9, 19, 22, 23, 29, 66, 68, 85

Fallopian tube, 35
Fletcher, Joseph, 45
Fogel, Dr. Julius, 72
Fourteenth Amendment, 16, 17, 22, 31, 46, 85
Frankl, Victor, 80
Functionary, man as, 12, 41, 57

Gardner, Dr. R. R. R., 17, 19, 20, 36
Genetic engineering, 64-66
Germany, x, 13, 14, 72
God-role, 7, 73, 84
Granfield, David, 45, 46
Guett, Dr. Arthur, 13
Guilt problems, 69-72, 78

Hawaii, state of, 21
Health, 6, 8, 9, 13, 66, 69, 71, 78, 83
Heartbeat, fetal, 17, 23, 25, 26
Hebrew view of man, 34
Heffernan, Dr. Bart, 23
Hegel, 7, 8
Heredity, 13
Hitler, 13
Huxley, Aldous, 12, 13

Illegitimacy, 75, 76
Illinois, state of, 22
Image of God in man, 10, 14, 30-41, 67
Implantation, 18, 25, 37
Incest, 21, 63, 67
Infanticide, 21
Innocence vs. guilt, 45, 46, 47, 51, 52, 53, 76
Inviolability, 11, 31, 39, 40, 41, 43, 44, 46, 47, 54

Judeo-Christian heritage, 5, 7, 10

Kantzer, Kenneth, 51
Keil-Delitzsch, 34
Kotulak, R., 70

Langone, John M., xi, 25, 28
Levine, Meldone E., xi, 64, 66

Life,
 biologic dimension of, 15, 16, 33
 gift of, 19, 20, 23, 31, 32, 33, 34, 36
 Webster's definition of, 15
Liley, Dr. Albert, 18, 20
Loss of life by abortion death, x, 49
Love vs. justice, 67

Man, historical beginning of, 32-38
Maryland, state of, 21
McCarthy, Colman, 72
Medical profession, role of, 5, 6, 8, 9, 17, 65, 66, 73
Minnesota Citizens Concerned For Life, 5
Minnesota, state of, 69, 70
Mores, morals, principles, ground of reality, 58, 59
Mountain States Women's Abortion Coalition, 16, 17, 55, 56
Murder,
 abortion as, 45-49
 as related to capital punishment and war, 53, 54
 as related to Exodus 21:22-25, 50-53
 definition of, 40, 43, 44
 ingredients of, 44, 45

Namecalling, 1, 2
Naturalism, 13, 59
Nebraska, state of, 22
New ethic, 5, 6, 8, 14, 22
New York, state of, 20, 21
Nietzsche, F., 13, 63
Nihilism, x, 14, 84

Ochs, Robert, 35
Old ethic, 5, 6, 8
Original sin, effects of, 39

Palmer, Edwin H., 50
Person or personhood,
 beginning of, 16-28, 33, 43, 84
 meaning of, 2, 11, 16, 28, 31, 39, 40, 41, 43
 protection of, 16, 17, 31, 46
Placenta, 18, 21, 23, 48
Population growth, 6, 73, 76

Postma, Dr. Edward Y., xi, 34-36
Potency, definition of, 36
Potential vs. actual, 17, 19, 36-38
Price tags, xi, 31, 84
Privacy, 57, 73, 74, 84
Product of conception, 2
Proposed human life amendment, 85

Quality of life, ix, x, 5, 6, 8, 11, 23, 47, 51, 64, 85
Quality-of-life culture, 12, 41, 63, 85
Quickening, 22

Rape, ix, 21, 45, 46, 47, 63, 67
Rational utility, principle of, 7, 8, 14
Relative value, x, 6, 51
Retardation or deformity, 11, 19, 39, 62, 63, 64
Right and wrong, 3, 7, 57, 58
Rights of the woman, 2, 73, 74
Right To Life Organization, x, 16, 64, 70
Roszak, Theodore, 9
Rubella, 62, 63

Sackett, (Florida Representative), 23
Sassone, Robert L., 13, 23
Self-fulfillment, 11, 58, 78, 79, 80
Self-sacrifice, 48
Sexual intercourse, 2, 3, 29, 36, 74
Sexual promiscuity, 12, 13
Sixth Commandment, 38, 44
Smedes, Lewis B., 34
Soul, man as, 14, 31, 33, 34, 35
Sperm and ovum, 24, 25, 28, 35, 37, 38, 65
Steinbeck, John, 56
Stob, Henry, 51
Stott, John R. W., 38
Suicide, 69, 70, 78, 85
Summerhill, Louise, 81
Supreme Court
 Illinois, 23
 United States, ix, 1, 3, 9, 16, 20, 21, 22, 24, 25, 62, 83, 84, 85

Technocracy, 7, 9, 65
Tedesco, Dr. Pietro C., 70
Ten Commandments, 7
Thielicke, Dr. Helmut, 14, 40, 41
Tournier, Dr. Paul, 71
Tunney, John V., xi, 64, 66
Tyranny, 12, 13, 62

Umbilical cord, 18, 20, 23
Unconditional love, x, 7, 10, 11, 12, 14, 79, 85
Unified being, man as, 34, 35
Unwanted child, 11, 12, 17, 66, 68, 79
Uterus, 25, 48

Viability, 22

Waltke, Bruce, 51
Williams, Dr. Robert H., 21
Willke, Dr. and Mrs. J. C., x, 21, 22, 24, 68

Zygote-embryo-fetus, 2, 3, 15, 16, 17, 19, 21, 23, 25, 34, 36, 37, 38, 74